2003

TRACEY MOFFATT

TRACEY MOFFATT

laudanum

Hatje Cantz Publishers

This project has been assisted
by the Commonwealth Government
through the Australia Council,
its arts funding and advisory body.

INHALT

VORWORT

Die Australierin Tracey Moffatt schafft in ihren fotografischen Folgen und Filmen Bildszenarien von großer Intensität. Scheinbar spielerisch verbindet die 39jährige Künstlerin effektvolle Stilisierung und inszenierte Künstlichkeit mit den Methoden der Dokumentation. Sie bezieht sich auf bekannte Bildtopoi aus der Geschichte von Film, Fotografie und bildender Kunst und übernimmt Stilmittel aus der Werbung und dem sogenannten Trash-TV. Im zeittypisch freien Zugriff der Künstlerin auf das visuelle »kollektive Gedächtnis« gibt es keine Wertung nach Hoch- oder Trivialkunst. Die mythischen Überlieferungen der australischen Ureinwohner und die angelsächsische Kultur der ehemaligen Kolonialisten mit ihren wechselseitigen Konflikten sind prägende Erfahrungen der Halb-Aborigine. Ihre Reflexion zieht sich durch das gesamte Werk. Moffatts emotionsgeladene Bildfolgen fügen sich nur selten zu geschlossenen Erzählungen zusammen. Im Zwischenbereich von Realität und Surrealem handeln sie von den existentiellen Themen Sexualität und Macht, Geburt und Tod, von Sehnsüchten, Träumen und Erinnerungen.

Seit der großen Ausstellung im Dia Center for the Arts, New York, im Jahr 1997/98 fanden Werke von Tracey Moffatt in vielen Ausstellungen auch des deutschsprachigen Raums große Beachtung. Wir freuen uns, daß wir nun, zeitgleich mit der Fundacio Caixa de Pensions in Barcelona, ihre neuen Fotoarbeiten vorstellen können. Dazu präsentieren wir vorangegangene Folgen und die wichtigsten Filme und bieten so einen Überblick über das Gesamtwerk der Künstlerin, die zur Zeit die bekannteste Repräsentantin der Avantgarde ihres Heimatlandes Australien ist.

Tracey Moffatt danken wir dafür, daß sie unser Projekt aus der Ferne wohlwollend begleitet hat. Lothar Albrecht, L.A. Galerie Frankfurt, unterstützte uns durch Leihgaben und Ratschläge. Barbara Renftle arbeitete mit an Ausstellung und Katalog, den Eduard Keller-Mack gestaltete. Ihnen allen, wie den Privatsammlern, die sich für unsere Ausstellung von Werken der Künstlerin trennen, sei ebenfalls herzlich gedankt.

Brigitte Reinhardt, Ulmer Museum

Alexander Tolnay, Neuer Berliner Kunstverein

Stephan Berg, Kunstverein Freiburg im Marienbad

PREFACE

The Australian Tracey Moffatt has created visual scenarios of striking intensity in her photographic series and films. With apparently playful ease, the 39-year-old artist combines highly effective stylisation and staged artificiality with techniques of documentation. She draws upon familiar images from film, photography and the visual arts and makes use of the stylistic resources of advertising and even so-called "trash TV". In the artist's typically contemporary free approach to the tapping of the visual "collective memory" we find no trace of judgmental distinction between high and popular art. The traditional myths of the Australian Aborigines, the Anglo-Saxon culture of the former colonial rulers and the conflicts engendered in the interaction between the two leave an indelible imprint on the work of Tracey Moffatt, a half-Aborigine herself. Her reflections on these subjects can be traced throughout her oeuvre. Only rarely do Moffatt's emotionally charged photo sequences merge together into cohesive narratives. Set in the imaginary realm between the real and the surreal, they deal with the fundamental existential themes of sexuality and power, birth and death, and with longings, dreams and memories.

During the months following the major exhibition at the Dia Center for the Arts, New York, in 1997/98, works by Tracey Moffatt have attracted significant interest at a number of exhibitions, including several in the German-speaking countries. We are very pleased to be able to present her recent photographic works in parallel with a show at the Fundacio Caixa de Pensions in Barcelona. Our exhibition also features previous series and the artist's most important films, thus providing a survey of the complete oeuvre of Tracey Moffatt, currently the most noteworthy representative of the avant-garde in her homeland of Australia.

We wish to thank Tracey Moffatt for the kind support she has provided for this project from afar. Lothar Albrecht of the L.A. Galerie Frankfurt assisted us with works on loan as well as valuable advice. Barbara Renftle made significant contributions to both the exhibition and the catalogue, which was designed by Eduard Keller-Mack. Our sincere thanks are due to them and to the private collectors who parted from works by the artist to help make our exhibition possible.

Brigitte Reinhardt, Ulmer Museum
Alexander Tolnay, Neuer Berliner Kunstverein
Stephan Berg, Kunstverein Freiburg im Marienbad

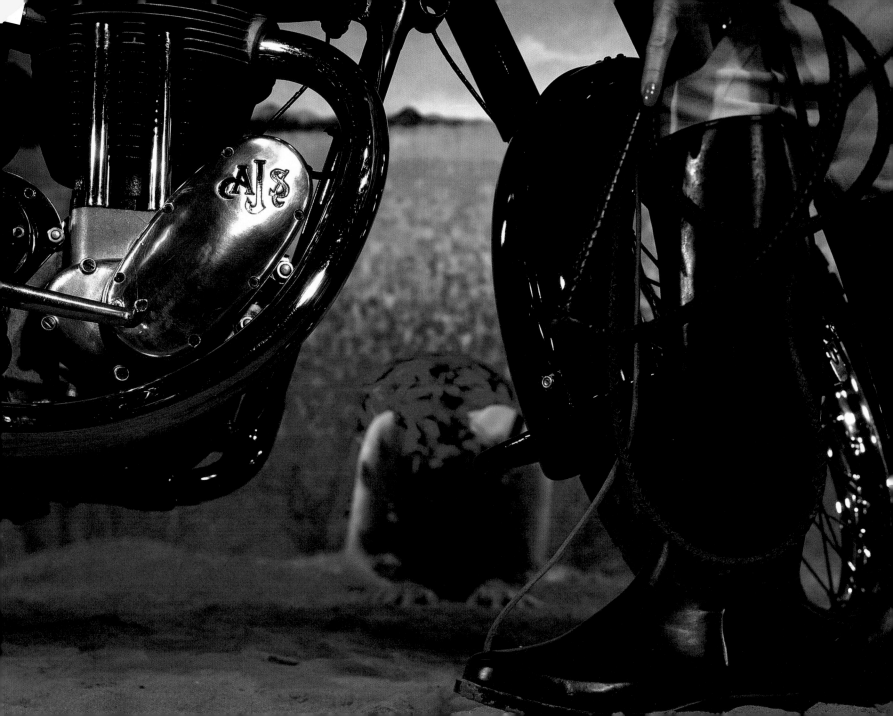

DIE EIGENE REALITÄT ERSCHAFFEN

Brigitte Reinhardt

Tracey Moffatts Foto- und Filmbilder handeln von den existentiellen Themen Sexualität und Macht, Geburt und Tod, von Sehnsüchten, Träumen und Erinnerungen. Ihre intensiven Figurationen scheinen dem flüchtigen Blick eine äußere Realität nachzuzeichnen. Tatsächlich sind sie jedoch stark stilisiert und mit lustvollem Bekenntnis zur Künstlichkeit sorgfältig arrangiert. Auch die zunächst eingängig erscheinenden Bildinhalte entziehen sich einer klaren Deutung. Moffatts Werke prägen sich daher dem Betrachter auf besondere Weise ein: Sinnlichkeit und innere Dramatik treffen direkt das Gefühl, während die verrätselte Lesbarkeit der Erzählungen und die starke Eigenwirkung auch einzelner Bildszenarien Distanz schaffen.

Die heute 39jährige Australierin begann ihre künstlerische Arbeit als Experimental- und Dokumentarfilmerin, sie beschäftigte sich auch mit Musicvideos. Nach dem Abschluß des Studiums »visual communications« am Queensland College of Art in ihrer Heimatstadt Brisbane im Jahr 1982 zog sie nach Sydney, wo sie, im Wechsel mit New York, heute noch lebt.

Moffatt führt das filmische Prinzip in der Fotografie fort. Ihre Aufnahmen entstehen ausschließlich als Folgen, die nach sorgfältig vorbereiteten Entwürfen und an eigens angemieteten Orten erarbeitet sind. Die Künstlerin, die in einigen ihrer frühen Fotoserien und Filmen selbst als Darstellerin agiert[1], setzt daher auch in der Fotografie relativ viele Mitarbeiter ein.

Ihre wache Aufnahmefähigkeit und ihr Bedürfnis, unterschiedlichste Eindrücke und Erlebnisse im Nachstellen und fotografischen Fixieren in etwas Eigenes zu verwandeln, wird schon in den drei einfachen Farbaufnahmen der 13 bzw. 14jährigen deutlich. Auf den 1998 als »Backyard Series« reproduzierten Fotos läßt sie Spielgefährten als Held des gerade aktuellen Filmes »Planet of the ape« mit Affenmaske und Umhang, in der Gruppe einer weihnachtlichen »Nativity Scene« oder als »Rock Star« auf dem Rasen des Hinterhofes posieren.

Das theaterhaft Inszenierte wird in den beiden ersten Werken, die Moffatt auch außerhalb Australiens bekannt machten, der Fotoserie »Something More« und dem Kurzfilm »Night Cries«, beide von 1989, durch gemalte, kulissenhaft zusammengebaute Landschaften und Requisiten beson-

1
in »Something More«, »Pet Thang«, »Bedevil«, »Scarred for Live«

Something More, 1989

9

ders deutlich. Die träumerische Bilderfolge »Pet Thang«, 1991, und die vier Jahre später vollendete vitale Roller-Derby-Queens Serie »Guapa« spielen, wenn auch auf ganz unterschiedliche Weise, vor einem neutralen Grund und wirken

von Raum und Zeit losgelöst. Vorgebliche Dokumentation wie bei »Scarred for Live«, 1994, die in »Up in the Sky«, 1997, zuweilen surreal überhöht und in der neuen Serie »laudanum« in einem historisierenden Ambiente angesiedelt ist, verdichtet sich später zu Schauplätzen von eindringlicher Präsenz.

Der innerhalb einer Folge wechselnde Farbcharakter der Fotografien schafft weitere Verfremdungen. So steht bei »Something more« toniges Schwarzweiß neben kräftiger, von leuchtendem Rot und Gelb bestimmter Farbigkeit, sind ganze Schwarzweiß Folgen in unterschiedlichen zarten Tönen eingefärbt.

Und doch wirkt jedes Bild als Teil einer spannungsvollen Erzählung, die sich in den übrigen Aufnahmen der Folge fortzusetzen scheint, die jedoch nur assoziativ weitergedacht werden kann. Moffatt definiert die von ihr vorgeschlagene Abfolge der Bilder nicht als zwingend. Sie legt nur den visuellen Anfang und das Ende ihrer Geschichten fest, die dazwischen liegenden Teile können als spotlichtartige Anreize zur Entfaltung der eigenen Phantasie gesehen werden. Der Eigentümer bzw. Kurator des Werkes soll das übrige Arrangement und damit die Interpretation in der Veränderung neu gestalten.

»I am not concerned with verysimilitude … I am not concerned with capturing reality, I'm concerned with creating it myself.«[2]

Tracey Moffatt entwickelt ihre Themen, wie sie sagt, aus einer mehr gefühlsmäßig zugelassenen als analytisch vergegenwärtigten persönlichen Rückerinnerung. Das eigene Erleben ist eine Basis der – zum Beispiel bei »Scarred for Live« – mit lakonischer Eindringlichkeit dargestellten Situationsbeschreibungen. Einen gewichtigen Anteil haben auch die Vorstellungen und die Auseinandersetzung der Künstlerin mit der Welt vorgefundener Visualisierungen, die ganz unterschiedlichen Medien wie Fernsehen, Werbung, Film oder Kunstgeschichte entnommen sind.

»Die Quelle aller meiner Bilder ist in meinem Unterbewußtsein, in meinen Träumen. Ich meine nicht die Träume, die ich nachts im Schlaf habe

2
Tracey Moffatt, zitiert in: Tracey Moffatt, Free-Falling, Ausstellungskatalog Dia Center for the Arts, New York 1998, S. 23

Something More, 1989

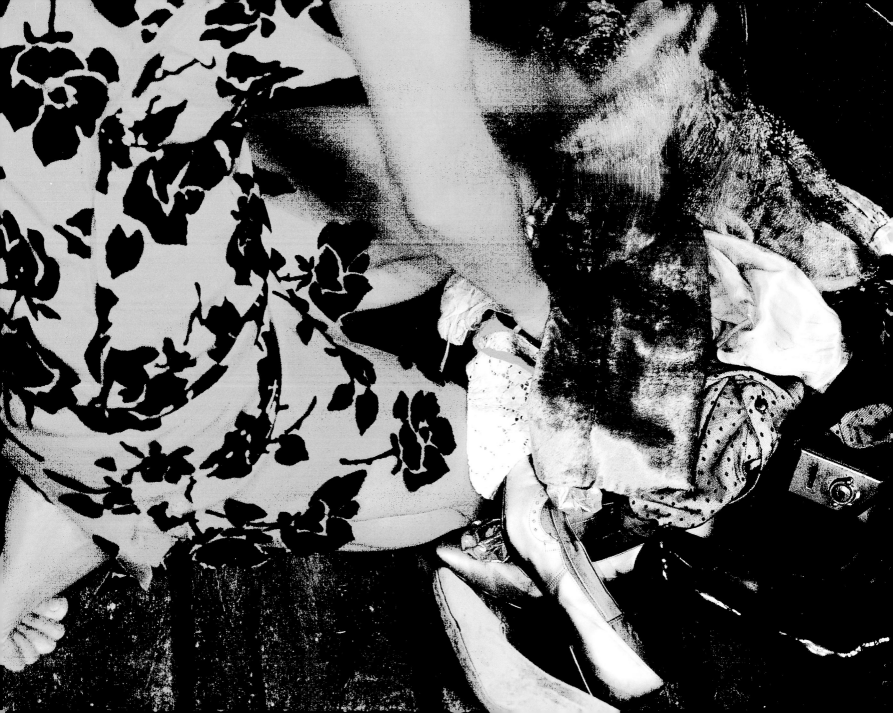

(die sind viel zu seltsam und bizarr), sondern die Träume, die ich im Wachen habe. Man kann auch mit offenen Augen träumen.«[3]

»Ich erschaffe gerne meine eigene Version der Realität – die Bilder kommen aus mir, aus dem, was ich kenne. Sachen, die ich gesehen oder erlebt habe, und Sachen, von denen ich meine, daß ich sie gesehen oder erlebt habe. Vielleicht ist es auch eine übersteigerte Version meiner Realität.«[4]

Zwischen sogenannter Hochkunst und Unterhaltung gibt es für Moffatt keinen Unterschied. Die Künstlerin bekennt sich vielmehr zur verführerischen Wirkung der klischeehaften, mit Emotionen aufgeladenen Bilder aus dem Trivialbereich und eignet sich deren Strategien an. Sie akzeptiert die Präsenz und Bedeutung der von ihnen geschaffenen oder repräsentierten Alltagsmythen, mit denen sie aufgewachsen ist und die Teil ihres Lebens sind. Das taten zuvor schon Andy Warhol und die Pop Art und danach viele andere. Moffatt setzt diese Bilder jedoch nun – fast zwei Generationen später – mit größerer Selbstverständlichkeit ein, mit einer Akzeptanz und Sinnlichkeit, denen Kritik oder zynischer Kommentar fern liegen.

Filme haben Tracey Moffatt, wie sie sagt, immer fasziniert, sie haben ihre Vorstellungswelt geformt und angeregt. Das Medium ist für sie ein wichtiger Ausgangspunkt ästhetischer und intellektueller Auseinandersetzung. Die Künstlerin nennt populäre australische Streifen wie Charles Chauvels »Jedda«, 1955, der den Konflikt zwischen weißen Kolonialisten und den unterdrückten Ureinwohnern am beispielhaften Schicksal eines Aborigines-Kindes melodramatisch behandelt, die Fernsehserie »Mad Max«, Filme von Pier Paolo Pasolini oder Martin Scorsese. Und sie bekennt sich zu einer »besondere(n) Leidenschaft für alles Europäische – für Sachen, die vor 1970 und in Schwarzweiß gedreht wurden, wie die Traumfilme von Jean Cocteau.«[5]

Moffatt entwickelt für jede neue Fotoserie und jeden neuen Film einen eigenen Charakter und stellt sich damit immer neuen ästhetischen und technischen Herausforderungen. Jede Arbeit ist jedoch durch ihre assoziationsreiche, vitale Sichtweise bestimmt, und prägende stilistische Mittel, wie der Wechsel extrem nahsichtiger Ausschnitte mit dem Blick auf weiter gefaßte Räume, werden immer wieder eingesetzt.

»Something More«, 1989, verweist auf neun farbigen und schwarzweißen Fotos auf die Geschichte des hoffnungsfrohen Aufbruchs einer jungen schönen Frau aus einfachen Verhältnissen zu einem »besseren« Leben in der fernen Großstadt und auf ihr Scheitern. Moffatt arbeitet bei der Inszenierung sehr direkt mit optischen Reizen der Werbung wie typisierter Vereinfachung und plakativem Bildaufbau. Die stofflichen Qualitäten der einzelnen Sujets sind in bestechender Präzision hervorgehoben, etwa das Changieren des

3
Tracey Moffatt, Ausstellungskatalog Wien, Stuttgart, Bozen, Bregenz, Stuttgart 1998, S.16

4
a.a.O. Stuttgart, S.17

5
a.a.O. Stuttgart, S.18

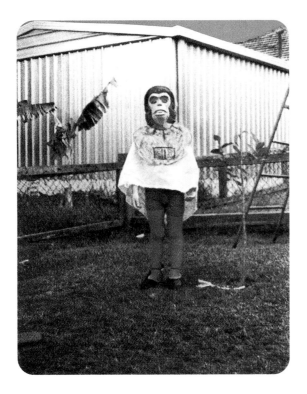 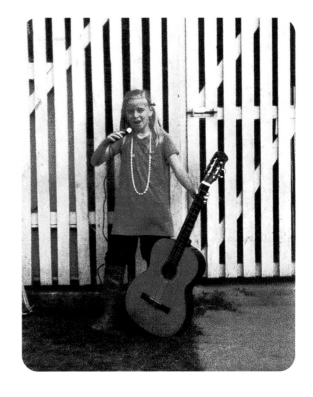

weich fließenden Seidenunterrocks neben der rauhen, verblichenen Bretterwand. Die Materialwirkung verstärkt sich noch durch extreme Nahsicht etwa auf das stillebenhafte Arrangement des mit schwarzen Rosen bestickten festlichen roten Kleides der Protagonistin und den glänzenden, mit Goldfäden durchwirkten Stoffen. Ein polierter Motorradmotor und gewichste schwarze Reitstiefel – Symbole der Macho-Männlichkeit – blinken neben dem frisch gelackten roten Finger

nagel, der die peitschetragende Person als Frau identifiziert.

Wie eine Traumphantasie wirken die sechs tonigen Farbfotografien von »Pet Thang«, die zwei Jahre später entstanden. In unwirklich schwebendem Nebeneinander tauchen Gesicht und Körper einer jungen Frau und eines Schafes bzw. Lammes aus tiefem Dunkel empor. Nackte glatte Haut steht neben gekräuseltem, weichem Fell. Die Ausstrahlung unterschiedlicher haptischer Sinnlich

keit und der spannungsvolle Wechsel von Nähe und Vereinzelung vermitteln eine somnambule Erotik voller Geheimnisse.

Die Farbaufnahmen »Scarred for Live« könnten dagegen auf den ersten Blick wie einfache Schnappschüsse aus dem Familienalbum wahrgenommen werden. Moffatt stellt neben die neun kleinformatigen Fotos kurze Texte und orientiert sich dabei am 60er Jahre – Layout der amerikanischen Zeitschrift »Life«.[6] Die Serie wurde 1994 im Offsetdruck aufgelegt. Ihren vorgeblich dokumentarischen Charakter verstärken Jahreszahlen zwischen 1956 und 1977, die den Bildtiteln beigefügt sind. Sie simulieren eine frühe Datierung der Aufnahmen, die der Atmosphäre und dem Handlungsrahmen des jeweiligen Bildes entspricht; die australische Fernsehserie »Telecam Guys« erreichte z.B. 1977 größte Popularität. Die Motive sind aus der Sicht des zufälligen Beobachters festgehalten. Ihre Zusammenschau mit den schriftlichen Kommentaren deckt alltägliche Verletzungen auf, die, oft eher beiläufig zugefügt, ein Leben lang nachwirken können.

»Guapa« wiederum, zehn Bilder des sportlichen Wettkampfs der »Roller-Derby-Queens«, ähnelt einer Choreographie aus Bewegung, Massierung und Vereinzelung im freien Raum. Moffatt zeigt das gemeinsame Einrollen, das Aufeinanderprallen und sich wieder Vereinzeln der kraftvollen jungen Frauen in extremen Perspektiven. Auch hier handelt es sich nicht um ein reales sportliches

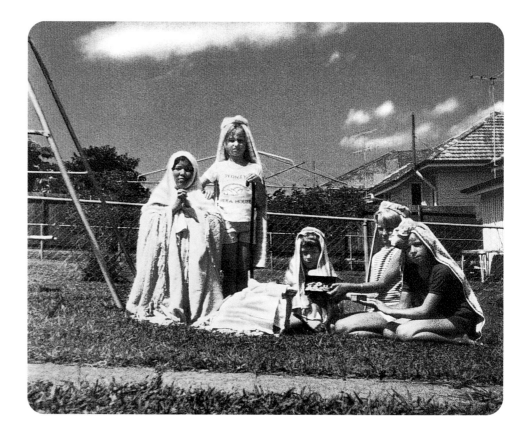

Ereignis, sondern um die Inszenierung in einem Studio, die die Künstlerin als Stipendiatin in San Antonio, Texas, 1994 veranlaßte. Der Kampf ist rauh, die Mienen und Gesten sind entschlossen, aggressiv, schließlich erschöpft, aber seine Wiedergabe erhält durch die pastellfarbige Tönung und Weichzeichnung vor hellem Grund Schwerelosigkeit und Abstraktion.

6
a.a.O. Stuttgart, S.22

Backyard Series, 1998

Die mit 25 Blättern bisher umfangreichste Folge »Up in the Sky«, 1997 als Offsetprints veröffentlicht, ist zugleich auch die bezugreichste und am schwersten lesbar. Moffatt hat, für den Betrachter nicht zu unterscheiden, unter ihre gestellten Bilder zufällig von ihr aufgenommene Fotos gemischt.[7] Der Blick ist nun weiter gefaßt und führt in das dünn besiedelte karge Outback am Rande der heißen Wüstenlandschaft Australiens, wo Aborigines und verarmte Weiße am Rande der Zivilisation zusammen leben. Mehrere Handlungsstränge stehen nebeneinander, bleiben aber fragmentarisch. Grundthema ist der harte Überlebenskampf, seine inneren und äußeren Bedrohungen, Rituale und bis zum Wahn gesteigerten Sehnsüchte, aber auch das ursprüngliche Erleben von Natur und Existenz. In der blonden weißen Frau mit dem farbigen Baby greift Moffatt das rund zehn Jahre zuvor behandelte Mutter-Kind Thema ihres Films »Night Cries« wieder auf. Spielen die Nonnen, die sich in ihrer schwarzen Tracht wie Raubvögel nähern und später das Kind in die Luft stemmen, auf den – für die Aborigines – sehr zwiespältigen Einfluß der christlichen Kirche an? Ähnlich wie in sozialrealistischen Filmen der 1960er Jahre monumentalisiert und erotisiert Moffatt den Blick auf proletarische körperliche Arbeit, hier der muskulösen Männer und Frauen, die Autowracks ausschlachten. Szenen wie das im Spiel werfende Mädchen oder die am Boden miteinander ringenden Männer schei-

nen – den Werken von Jeff Wall vergleichbar – in der Bewegung gleichsam eingefroren und damit aus der Zeitlichkeit genommen.

Mit ihrer neuen, 19teiligen Serie »laudanum« kehrt Moffatt zu einem mehr in sich geschlossenen Szenarium zurück. Wie bei »Something more« sind die Hauptpersonen zwei Frauen, hier die weiße Herrin und ihre Dienerin, eine junge Aborigine. Sie scheinen in einem erotischen Machtverhältnis miteinander verbunden zu sein, das erzählerisch wie atmosphärisch eingebettet ist in das historisierende Ambiente eines herrschaftlichen Kolonialhauses der Jahrhundertwende. Anfang- und Endsequenz spielen an der gleichen Stelle der repräsentativen Halle. Die gepflegte »Herrin«, vor der die »Dienerin« neben dem Putzeimer anfangs untertänig auf dem Boden liegt, kauert später halbnackt auf der Treppe – den Platz der Dienerin nimmt ein verschnürtes Bündel ein. Dazwischen irrlichtern Bilder der Frauen, als Einzelne, nebeneinander im Raum oder durch Überblendungen beieinander, halbentkleidet und nackt, in sinnlicher Versenkung oder wahnartiger Erregung, einander quälend und unterwerfend.

Moffatts expressives Stimmungsbild einer morbiden Fin de siècle-Gesellschaft, deren hysterische Erscheinungen, deren sado-masochistische Lust und deren Verfall mit dem Rauschmittel Laudanum – Opium – verquickt ist, wurde von einer erotischen Erzählung angeregt.[8]

7
a.a.O. Stuttgart, S.17

8
Pauline Reage, »Story of O«, 1954

Schauplatz der Inszenierungen sind denkmalge-
schützte Gebäude in Sydney. Die Künstlerin setzt
verschwenderisch den nostalgischen Reiz alter
Fotografien ein, stellt dabei erotische Kunstphotos
der Zeit um 1900 nach, und steigert die mystische
Wirkung mit extremen Stilmitteln des Expressio-
nismus zum Melodram. So scheinen die schatten-
haften Verzerrungen dem deutschen Filmklassiker
»Nosferatu« von F. M. Murnau entnommen, dem
1921 gedrehten Vorbild vieler »Horrorfilme«.
Unschärfen, Kratzer, Schrammen und die – Dop-
pelbelichtung assoziierenden – Überblendungen
der beiden Frauen verstärken den historischen
Eindruck der Aufnahmen. Dem entspricht auch
die Reproduktion in dem traditionellen Verfahren
der Fotogravüre, die den Bildern ihre matte
Tönung und damit einen weiteren Anschein von
Alter und von Kostbarkeit gibt.

 Mit der Variation der inhaltlich-athmosphäri-
schen Aussagen und der ihnen entsprechenden
äußeren Form wechselt Moffatt also auch zwi-
schen einer mehr geschlossenen und einer locke-
rer assoziierenden Erzählstruktur. Durch alle Bild-
folgen zieht sich jedoch die Beschäftigung mit
Sexualität und Macht, entwickelt an Situationen
des Frau-Seins und rassischen Konflikten ihrer
Heimat Australien. Diese Auseinandersetzung be-
stimmt fast noch stärker die Grundthemen ihrer
Filme. In »Night Cries: A Rural Tragedy«, Moffatts
bekanntestem Kurzfilm, verarbeitet die 29jährige
ihre eigene Geschichte: Als Halb-Aborigine-Kind

wurde sie, der damaligen Gesetzgebung ent-
sprechend, einer weißen Familie zur Adoption
überlassen. Im Film pflegt eine erwachsene Abo-
riginefrau zwischen Haß und widerwilliger
Zuneigung die todkranke Adoptivmutter, die
schließlich stirbt. Moffatt inszeniert den lakoni-
schen Bericht extrem künstlich als »Tragödie«
von großer emotionaler Dichte und mit eindring-
lichen Stimmungen. Zuvor hatte sie Dokumentar-
filme über Lebensumstände und politische Anlie-
gen der Aborigines gedreht. Auch »Nice Colored
Girls«, ihr erster, 1987 entstandener Kurzfilm und
»Bedevil«, den sie sechs Jahre später als ersten
Streifen in Spielfilmlänge vollendete, reflektieren
Schicksal und Mythen dieser gesellschaftlich un-

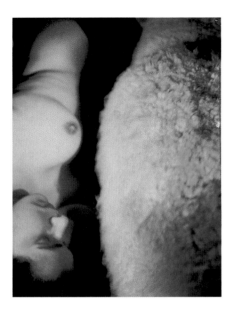

Pet Thang, 1991

terdrückten Minderheit. Die Geschichte der Aboriginesmädchen, die beim nächtlichen Ausgehen einen weißen, angetrunkenen »Freier« bestehlen und denen in kurzen Rückblenden die Gesichter ihrer kolonialisierten Urgroßmütter konfrontiert sind, spielt in der Gegenwart, in einer modernen Stadt. Die unheimliche Atmosphäre der wabernden Sumpflandschaft in »Bedevil« scheint dagegen erfüllt von rätselhaften Mythen der australischen Ureinwohner, in die auch die Geschehnisse zwischen farbigen und weißen Kindern eingebunden sind.

Moffatt klagt in ihren Fotoserien und Filmen jedoch nicht an, ihr liegt nicht an politischer Agitation im Sinne des Feminismus oder rassischer Gleichstellung. Ihr Blick auf das andere Geschlecht ist unverkrampft und selbstbewußt, wenn sie z.B. als 26jährige »Some Lads«, farbige Tänzer-Freunde, für die 1998 aufgelegten Fotos spielerisch ihre Körper präsentieren läßt oder elf Jahre später in »Heaven« die Videokamera in ein weibliches Auge verwandelt, das mit nachsichtigem Spott Surfer beim mehr oder weniger schamhaften Umziehen im Schutz ihrer Autos beobachtet und provoziert. Das Wissen und die eigene Erfahrung von gesellschaftlichen Problemen und Ungerechtigkeiten sind immer präsent. Sie sind jedoch eingebunden und überhöht in Bildern, deren Poesie, deren ironisches Spiel und ästhetische Kraft eigenständige neue Wirklichkeiten erschaffen.

17

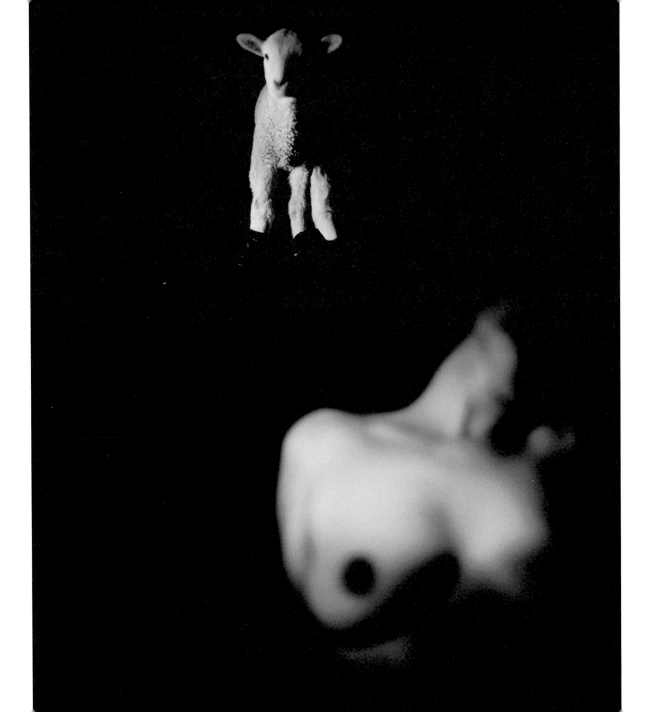

CREATING ONE'S OWN REALITY

Brigitte Reinhardt

Tracey Moffatt's photo and film images deal with the fundamental, existential themes of sexuality and power, birth and death, yearnings, dreams and memories. At first glance, her vivid figural imagery appears to trace the outlines of an external reality. Yet it is actually highly stylised and arranged in a pleasureful embrace of artificiality. Even those elements of pictorial content which seem so neat and succinct at first ultimately defy clear interpretation. Thus Moffatt's photographs make a very special kind of impression on the viewer. Sensuality and inner drama go directly to the heart, while the puzzling narrative components and the autonomous power of isolated visual scenarios create a distancing effect.

The thirty-nine-year-old Australian artist began her career in art as a maker of experimental and documentary films and was also involved in the production of music videos. After completing her studies in Visual Communications at the Queensland College of Art in her native city of Brisbane in 1982, she moved to Sydney, where she lives today, while maintaining a second residence in New York.

Moffatt pursues cinematic principles in her photography as well. Her pictures are done exclusively in series developed on the basis of carefully prepared concepts at locations rented for her purposes. The artist, who appears as a performer in some of her earlier photo series and films,[1] also employs a relatively large staff of people for her photography.

Her alert receptiveness and her desire to transform a wide variety of impressions and experiences into something of her own by tracking them down and capturing them in photographs are already quite evident in three colour photos she made at the age of thirteen and fourteen. In these photographs, reproduced in 1998 as the *Backyard Series*, she had playmates pose as the hero of *Planet of the Apes*, a popular movie at the time, wearing ape masks and a cloak, in a group nativity scene at Christmas and as a rock star on the lawn of her back yard.

The importance of theatrical staging becomes particularly obvious in the two works that first earned Moffatt's recognition outside Australia, the photo series *Something More* and the short film *Night Cries*, both done in 1989, where she uses painted landscapes assembled in the manner of stage sets. The dreamlike series entitled *Pet Thang* (1991) and the vital roller-derby queen series *Guapa*, completed four years later, are played out – albeit in very different ways – against neutral backgrounds and appear detached from space and time. The illusion of documentation apparent in *Scarred for Life* (1994), which is exaggerated in places to the level of the surreal in *Up in the Sky* (1997) and placed in a mock-historical setting in

1
In *Something More, Pet Thang, Bedevil* and *Scarred for Life.*

Pet Thang, 1991

19

the new *laudanum* series, is later concentrated into scenes of penetrating immediacy.

The changing colour character of the photographs within a given series generates additional alienating effects. In *Something More*, for example, stark black-and-white appears alongside vigorous coloration dominated by red and yellow, while entire black-and-white series are tinted in various delicate hues.

Yet each photo has the look of a segment of a suspense-filled narrative that seems to be continued in the other pictures, although it is possible to make all the associative links needed to think it through to its conclusion. Moffatt does not define her choice of sequence as the only possible one. She specifies only the visual beginning and end of her stories, leaving the parts in between to stimulate the viewer's imagination as highlights, so to speak. The owner or the curator exhibiting the series is expected to decide upon the remainder of the sequential arrangement and thus to shape its interpretation through the changes he or she makes. "I am not concerned with verisimilitude … I am not concerned with capturing reality. I'm concerned with creating it myself." [2]

Tracey Moffatt develops her themes, as she says herself, on the basis of personal memories conditioned more by her feelings than by her analytical acuity. Her own experience provides a foundation – in *Scarred for Life*, for example – for descriptions of situations presented with laconic immediacy. A prominent role is also played by the artist's ideas and her concern with the world of found visual images drawn from such distinctly different media as television, advertising, film or art history.

"The source for all my pictures is in my subconscious mind, in my dreams. I don't mean the dreams I have in my sleep at night (they are much too strange and bizarre) but the ones I have when I'm awake. You can dream with your eyes open, too." [3]

"I love creating my own version of reality – the images come from inside, from the things I'm familiar with. Things I've seen or experienced and things I think I've seen or experienced. Perhaps it's also an exaggerated version of my own reality." [4]

Moffatt makes no distinction between so-called high art and entertainment. Instead, she openly accepts the seductive effects of cliché-ridden, emotionally charged images from the realm of popular culture and appropriates their strategies for her own purposes. She accepts the existence and the significance of the everyday myths engendered or represented by these images, myths with which she has grown up and which have become a part of her life. Andy Warhol, the Pop Artists and many others who followed did much the same before her. Today, however, she employs these same images – nearly two generations later – in a much more matter-of-fact manner and with a sense of acceptance and sensuality that has nothing in common with cynical commentary.

Movies have always fascinated Tracey Moffatt, as she confesses herself. They have shaped and inspired the world of her imagination. The medium of film offers her an important starting point for aesthetic and intellectual activity. The artist cites popular Australian films such as Charles Chauvel's *Jedda* (1955), a melodramatic treatment of the conflict between white colonists and the sup-

2
Tracey Moffatt, quoted from *Tracey Moffatt: Free-Falling*, exh. cat., Dia Center for the Arts (New York, 1983), p. 23.

3
Tracey Moffatt, exh. cat., Vienna, Stuttgart, Bozen, Bregenz (Stuttgart, 1998), p. 16.
4
op. cit. (Stuttgart, 1998), p. 17.

5
op. cit. (Stuttgart, 1998), p. 18.

Scarred for Life, 1994

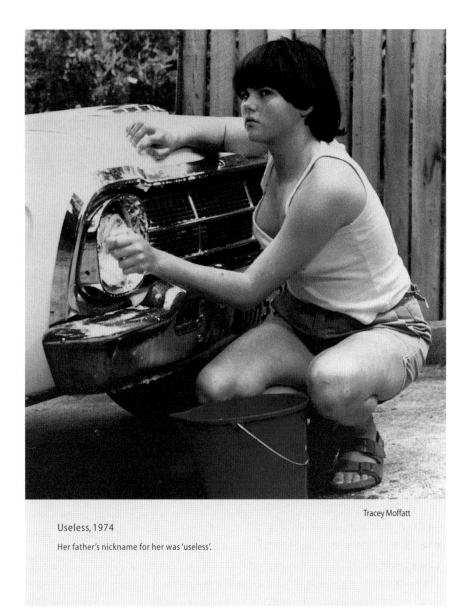

Useless, 1974

Her father's nickname for her was 'useless'.

Tracey Moffatt

pressed native population told as the story of an aborigine child, the *Mad Max* series, films by Pier Paolo Pasolini and Martin Scorsese. And she professes a "special passion for everything European – for things filmed before 1970 in black-and-white, like the dream films of Jean Cocteau."[5]

Moffatt gives each new photo series and every new film a character of its own, exposing herself in the process to a succession of new aesthetic and technical challenges. Each work is shaped by her richly associative, vital mode of vision, and accent-setting stylistic means, such as the juxtaposition of extreme close-up details with view of broader expanses of space, appear again and again.

In nine colour and black-and-white photos, *Something More* (1989) alludes to the story of the a beautiful young woman of modest circumstances who ventures forth with great hopes for a "better life" in the distant big city and ultimately fails in her quest. In staging her photos, Moffatt makes direct use of such visual appeals of advertising as stereotyping and provocative pictorial composition. The material qualities of the individual subjects are emphasised with brilliant precision – the shimmering texture of the softly flowing silk slip against the rough, bleached board wall, for example. The effect of materiality is intensified through the use of extreme close-up, as in the view of the still-life-style arrangement of the protagonist's festive red dress with its embroidered black roses and the lustrous fabrics interwoven with gold threads. A shiny motorcycle engine and polished black riding boots – symbols of macho-masculinity – sparkle alongside freshly polished fingernails that identify the person holding the whip as a woman.

21

The six earth-toned colour photographs from the *Pet Thang* series, done two years later, call to mind a dream fantasy. Appearing to float in the air next to one another in an unreal vision, the face and the body of a young woman and a sheep or lamb emerge from deep darkness. Smooth, naked skin is presented next to a curly, soft coat of wool. The aura of different forms of haptic sensuality and the tension created in the alternation between proximity and isolation suggest a somnambulant eroticism full of mystery.

The colour photos in *Scarred for Life*, on the other hand, could be taken at first glance for snapshots from a family album. Moffatt places brief texts alongside the small photos in an approach reminiscent of the layout of the American magazine *Life* during the sixties.[6] The series was published in offset in 1994. Its pretence of documentary character is underscored by the numbers representing the years between 1956 and 1977 that appear with the captions. They simulate an early dating of the photos that is in keeping with their respective atmospheres and narrative contexts. The Australian TV series *Telecam Guys* reached the height of its popularity in 1977, for example. The motifs are captured from the viewpoint of a random observer. Presented alongside the written commentaries, they allude to everyday injuries which, although often inadvertently inflicted, leave behind traces that may last a lifetime.

In contrast, *Guapa*, a series of ten photographs of competing roller-derby queens, resembles a choreography of movement, concentration and isolation in open space. Using extreme perspectives, Moffatt shows the powerful

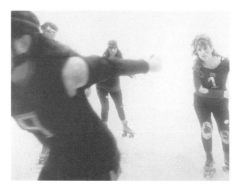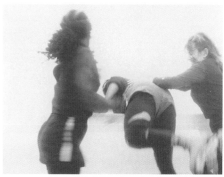

young women entering the arena together, crashing into one another and then going their separate ways again. Here as well, what we witness is not a real sports event but a staged studio production undertaken by the artist while working on a grant in San Antonio, Texas in 1994. The competition is rough, the women's expressions show determination, aggressiveness, ultimately exhaustion, yet the pastel tones and effect of soft-focus against a light background gives its presentation a sense of weightlessness and abstraction.

Moffatt's largest series, *Up in the Sky*, published as offset prints in 1997, is also the most richly referential and obscure of her serial works. Here, she has included photos taken at random amongst her stages images – although the viewer cannot tell the difference.[7] The perspective is now broader and leads into the sere, sparsely populated Outback on the fringe of Australia's hot desert landscape, where Aborigines and poor white people live together on the edge of civilisation.

Several different plot sequences emerge together but remain fragmentary. The underlying theme is the hard

6
op. cit. (Stuttgart, 1998), p. 22.

7
op. cit. (Stuttgart, 1998), p. 17.

Guapa, 1995

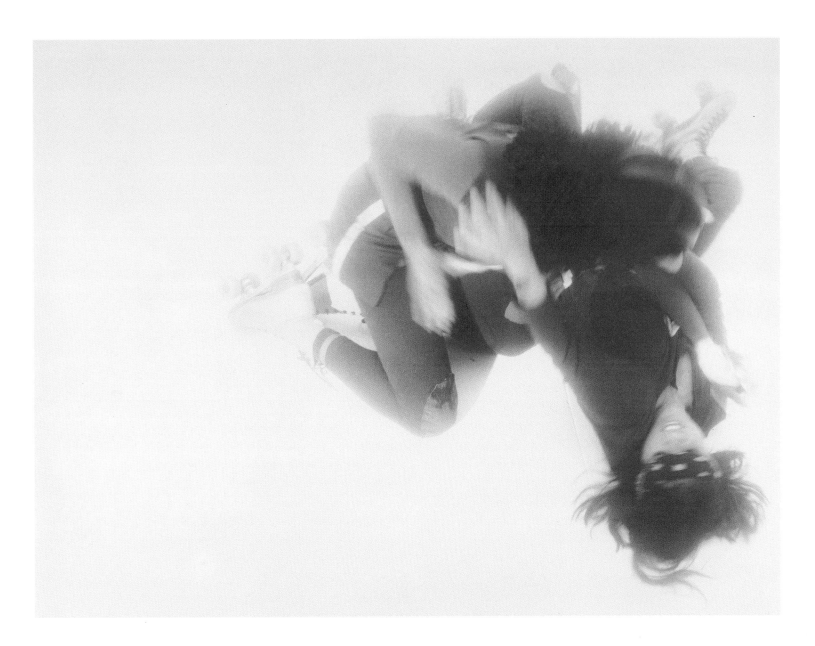

 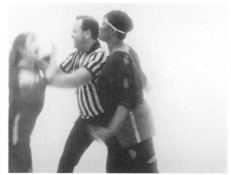 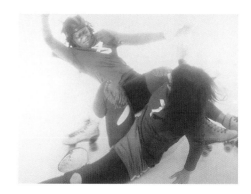

struggle for survival, the internal and external threats it poses, its rituals and the often obsessive yearnings it engenders, but also the primal experience of nature and existence. The image of the blonde white woman with the coloured baby signals Moffatt's returns to the mother-and-child theme with which she had dealt ten years before in her film *Night Cries*. Are the nuns seen approaching like birds of prey in their black habits, who later lift the child up into the air, an allusion to the influence of the Christian missionaries – an influence viewed by the Aborigines with great ambivalence? In the manner of social-realist films of the sixties, Moffatt monumentalises and eroticises the image of proletarian physical labour, seen here in the muscular men and women dismantling wrecked cars. Scenes like that of the girl playfully tossing rings or men wrestling on the ground have the appearance of freeze frames – calling to mind the works of Jeff Wall – and thus seem entirely removed from the realm of time.

With her new, nineteen-part series *laudanum*, Moffatt returns to a more internally cohesive scenario. As in *Some-thing More*, the protagonists are two women – in this case a white woman and her young Aborigine servant. The two appear to be joined in an erotic relationship, a power struggle that is embedded in both narrative and atmospheric terms in the historical ambience of a turn-of-the-century colonial mansion. The beginning and closing scenes are set in the imposing banquet hall. The elegant "mistress", before whom the "servant" lies on the floor next to a mop bucket in a posture of subjection, is later seen crouching half-naked on the stairs – the servant's place occupied by a tightly bound bundle. Sandwiched between these two scenes are momentary images of the two women, alone, standing side by side in a room or superimposed one upon the other in various stages of nudity, immersed in sensual reverie or in the throes of obsessive ecstasy, tormenting and subjugating one another.

Moffatt's expressive atmospheric portrait of a morbid fin-de-siècle society, whose hysterical manifestations, whose sado-masochistic lust and whose decline is closely related to the narcotic laudanum – opium, was inspired by

8
Pauline Reage, *Story of O* (1954).

Guapa, 1995

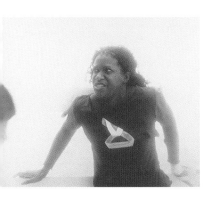

an erotic tale.[8] The staged photos were made in buildings under protection as historical monuments in Sydney. The artist makes lavish use of the nostalgic appeal of old photographs, intensifying the effect of mysticism to the point of melodrama with the extreme, expressionistic tools of the Expressionists. The shadowy distortions call to mind F. M. Murnau's classic German film *Nosferatu* of 1921, the model for numerous horror movies in later years. Areas of poor focus, scratches, flaws and the superimposed images of the two women – suggestive of double-exposure – heighten the impression that these are historical photographs. Accordingly, the images are reproduced in the traditional photogravure technique, which gives the photos their dull tones and thus contributes further to their appearance as old, precious pictures.

While varying the thematic-atmospheric messages and their corresponding external forms, Moffatt also alternates between rather more closed and relatively loosely associative narrative structures. The theme of sex and power, articulated in situations focused upon woman-

hood and racial conflicts in her native Australia, is a thread that links all of the sequences together. It is a concern that has an even greater influence upon the themes that underlie her films.

In *Night Cries: A Rural Tragedy*, Moffatt's best-known short feature, the artist looks back upon her own history from her vantage point at the age of twenty-nine. Born half white, half Aborigine, she was offered for adoption by a white family in compliance with the laws in force at the time. In the movie, an adult Aborigine woman nurses her terminally ill adoptive mother, struggling with feelings of hate and reluctant affection, until her death. Moffatt directs the laconic account with extreme artifice as a "tragedy" of great emotional intensity and strikingly evocative moods.

Earlier in her career she had made documentary films about the living conditions and the political concerns of the Aborigines. *Nice Colored Girls* (1987), her first short feature, and *Bedevil*, her first full-length film (completed five years later), reflect upon the fate and the myths of this

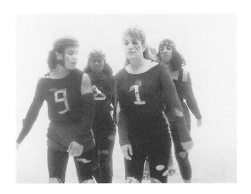

socially disadvantaged minority. The story of the Aborigine girls who rob a drunken white man during a night on the town and are then confronted in brief flashbacks with the faces of their great grandmothers during the era of colonial rule is set in the present, in a modern city. In contrast, the eerie atmosphere of the shifting, swampy landscape in *Bedevil* seems to conjure up the mysterious myths of the original natives of Australia, with which the encounters between white and coloured children are closely bound together.

Yet Moffatt does not accuse in her films or photo series. Her aim is not political agitation on behalf of feminist goals or racial equality. Her view of the opposite sex is relaxed and self-assured, as is evident, for example, in her *Some Lads* series, photos published in 1998 in which she (at age 26) showed coloured dancer-friends playfully displaying their bodies, or in *Heaven*, a film done eleven years later in which she transformed the video camera into a female eye that observes and provokes with a mixture of tolerance and scorn as it watches surfers modestly or less modestly changing their clothes in their cars. Her knowledge and her own experience of social problems and inequalities are always present. Yet they are incorporated into images whose poetry, ironic inventiveness and aesthetic power create truly new and independent realities.

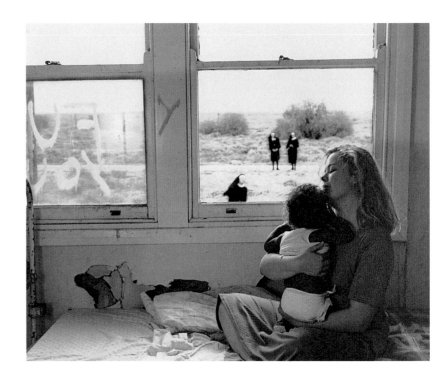

Up in the Sky, 1997

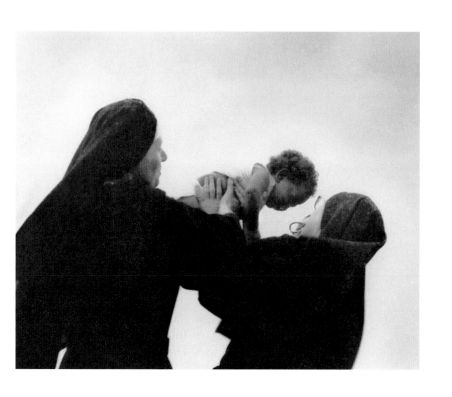

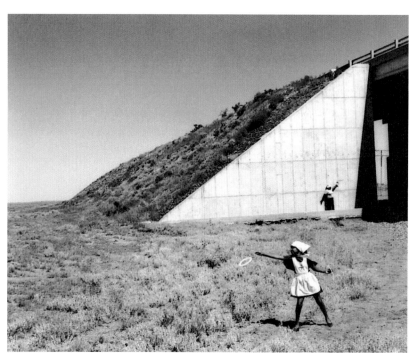

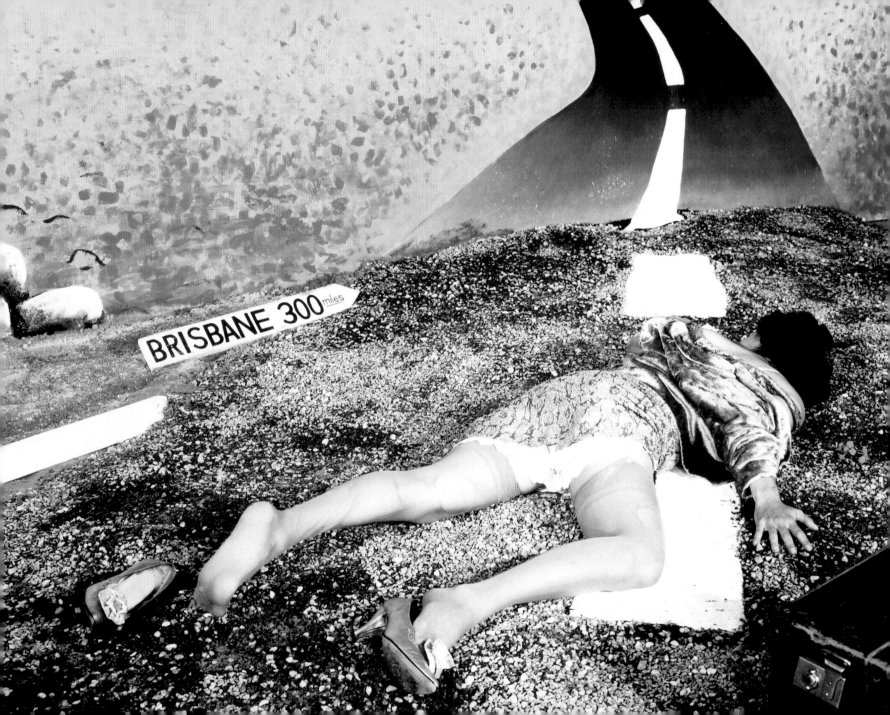

IRGENDWO

Stephan Berg

Am Ende des 1989 entstandenen ›Fotozyklus‹ »Something More«, mit dem Tracey Moffatt Anfang der neunziger Jahre schlagartig international bekannt wurde, steht ein Bild, das als Metapher für einen großen Teil der bisherigen Arbeit der australischen Künstlerin gelesen werden kann. Das schwarz-weiß Foto zeigt die »Heldin« der Bildfolge bäuchlings auf dem Mittelstreifen einer mit Kies bedeckten Straße liegen, die sich als gemaltes Band in den Hintergrund fortsetzt (der offensichtlich in Wirklichkeit aus einer Wand besteht). Ein auf dem Boden liegendes Schild informiert uns darüber, daß wir uns dreihundert Meilen entfernt von Brisbane befinden. Die Haltung der liegenden Frau – ohne Schuhe und mit hochgerutschtem Rock, der ihren Slip entblößt – könnte auf ein Verbrechen hindeuten, dem sie zum Opfer gefallen ist. Aber sicher können wir uns darüber nicht sein. Das Bildarrangement ist gerade so gehalten, daß wir gezwungen sind, einen narrativen Zusammenhang zu suchen, den wir gleichzeitig nicht finden können, weil die Konstellation so offen formuliert ist, daß sie nur mehrdeutige Lesarten erlaubt. Genausowenig klare, fixierbare Anhaltspunkte liefert das Foto in

Bezug auf den konkreten Ort und den Zeitpunkt der Handlung. Die Verschränkung von kulissenhaften und realen, gleichwohl arrangiert wirkenden Elementen rückt die Situation, ungeachtet des Straßenschildes, in den Bereich einer jenseits aller Realität und Fiktion siedelnden strukturellen Ort- und Zeitlosigkeit.

Daran ändert auch die Tatsache nichts, daß Tracey Moffatt, die die Frau dieser Bildfolge spielt, selbst aus Brisbane stammt. Im Gegenteil: Gerade im Spiel mit den autobiographischen Momenten zeigt sich die Unmöglichkeit sie autobiographisch zu lesen. Sowenig sich Tracey Moffatt mit der »Heldin« der Fotoserie identifizieren läßt, sowenig ist Brisbane hier vor dem Hintergrund der realen Stadt zu lesen. Dem deiktischen Hinweis auf diesen Ort kommt allein dramaturgische Bedeutung zu. Er bezeichnet eine Distanz, die die auf der Straße liegende Frau in ihrem Zustand nicht mehr bewältigen kann. Im Verweis auf die australische Stadt, die für die Protagonistin ebenso weit entfernt liegt wie der Mond, wird die Entrücktheit und Entfernung von jeder Realität deutlich, die diese Situation kennzeichnet: Kein Ort nirgends – nur das mittelstreifengesäumte Band der

Straße, das aus dem Nichts des Bildvordergrundes in das Nichts der oberen Bildbegrenzung führt.

Diese zwischen Surrealität und Traumlogik oszillierende Ortlosigkeit läßt sich – bis auf die Ausnahmearbeit »Scarred for Life« – in allen Arbeiten Tracey Moffatts bis hin zu »laudanum« beobachten, und gilt in besonderer Weise für den 1997 entstandenen fünfundzwanzigteiligen Fotozyklus »Up in the Sky«. Es ist verschiedentlich hervorgehoben worden, daß die Arbeiten Tracey Moffatts »vor allem um den Austausch von Konflikten zu kreisen scheinen, wobei der Gegenstand des Konfliktes der menschliche Körper ist«[1] Ebenso wichtig scheint aber die Beobachtung, daß diese Antagonismen zwar räumlich gefaßt werden (mit der Ausnahme von »Guapa«, wo sich das Geschehen in milchig weißem Studio-Nichts abspielt), dabei aber im Grunde nie die Dichte einer konkreten Topografie erlangen. Auch in »Up in the Sky« enthalten die auf ockerfarben und stahlblau koloriertem Papier abgezogenen Aufnahmen nur scheinbar konsistente Informationen zur Lokalisierung des Geschehens. Barackenartige Wellblechhäuser, ein Teil einer betonierten Brückenunterführung, Ausschnitte aus einem Innenraum, Bäume und Stromleitungen illusionieren so etwas wie ein räumliches Gerüst, in das die handelnden Personen gestellt werden, ohne daß sie ihm wirklich zuzuordnen wären.

Obwohl Tracey Moffatt in dieser Folge völlig ohne Kulissen arbeitet, erscheint die zugrunde-liegende Realität des »Outbacks« der australischen Steppe eben nicht als Wirklichkeit, sondern als inszeniertes Surrogat. Das Fundament dieser Inszenierung aber ist, ähnlich wie in »Something More« eine grundsätzliche ort- und zeitlose Leere, eine »tabula rasa«, zerschnitten allein durch das weiß linierte Band der Straße, die wiederum nicht erkennen läßt, daß man auf ihr zu irgendeinem Ziel gelangen könnte. Im Gegenteil: Das Bildmotiv eines am Straßenrand wartenden Jeeps mit eingeschalteten Scheinwerfern, vor dem sich ein alter abgerissener Mann in dreckigem Unterhemd und kurzen Hosen auf allen Vieren quer über die Straße, erst in die eine, dann wieder in die andere Richtung bewegt, deutet den Wechsel von der linearen Erschließung des Raumes und zielorientierter Bewegung hin zu einer Form des vibrierenden Stillstandes ebenso an, wie das Motiv der Männer und Frauen, die mit Vorschlaghämmern auf restlos demolierten Schrottautos stehen.

Eben diese Bilder lassen sich zudem unschwer mit den ersten beiden »Mad Max«-Filmen in Verbindung bringen, die Tracey Moffatt erklärtermaßen beeinflußt haben[2]. Mad Max erzählt eine Endzeitparabel aus einer Welt, in der zivilisatorische Grundprinzipien nicht mehr gelten, Städte und funktionierende Gemeinschaften nicht mehr existieren, sondern nur noch endlose Straßen, auf denen sich apokalyptische, hochmotorisierte Gangs einen erbitterten Kampf um Benzin liefern. Benzin als Treibstoff der Bewegung ist nicht nur

1
John Yau: Wettkampf, in: Tracey Moffatt, Kunsthalle Wien et al., Ausstellungskatalog (Hrsg. Martin Hentschel, Gerald Matt) Ostfildern-Ruit; Cantz, 1998, S.12

2
Vgl. Interview Gerald Matt mit Tracey Moffatt, in: Tracey Moffatt, Anm. a.o., S.18

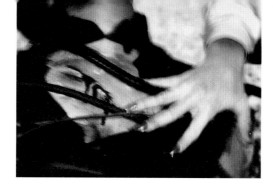

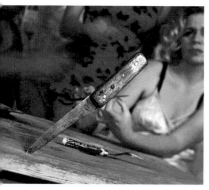

das Motiv, das den Film vorantreibt und damit das Medium selbstreflexiv kommentiert, der Kampf um diesen Treibstoff ist gleichzeitig auch eine Metapher für die in sich kreisende Sinnlosigkeit der damit ermöglichten Fahrten, die stets nur von einem Nichts in das nächste Nichts führen. So erzählt der Film, bei maximaler äußerer Dynamik auch von maximalem innerem Stillstand. Und er erzählt von der Verwandlung des »guten« Polizisten Max in die Kunstfigur des Mad Max, der – ganz in schwarzes Leder gehüllt – seinen herkömmlichen Polizeiwagen gegen einen superschnellen V 8 eintauscht und in symbolischer Vereinigung mit dieser hochgezüchteten Junggesellenmaschine in den Wahnsinn rast und ihn so buchstäblich am eigenen Leib er-fährt.

»Up in the sky« greift – wie oben erwähnt – einige zentrale Momente dieser filmischen Konstellation auf, bis hin zu der destruktiven Kopplung von Mensch und Maschine, die in den mit den Schrottautos verschmelzenden männlichen Körpern deutlich wird, hält aber das Ergebnis – auch durch Einschübe anders gelagerter Motive – sehr viel stärker in der Schwebe. Dieses Moment

der Unentscheidbarkeit und strukturellen Uneindeutigkeit betrifft neben der räumlichen Verankerung, vor allem die Erzählhaltung innerhalb der Arbeit. Im Unterschied zu den vorausgegangenen Serien »Something More«, »Pet Thang«, »Guapa« oder der 1998 entstandenen Arbeit »laudanum«, vermischt Tracey Moffatt in »Up in the Sky« mehrere völlig unabhängig voneinander verlaufende Handlungsstränge miteinander. Dabei erscheint schon das Wort »Handlungsstrang« eigentlich fehl am Platz, denn die Künstlerin präsentiert uns eher fragmentarische Momente, Augenblicke, deren Kohärenz untereinander außerordentlich fragil ist. Dies zumal, als die Künstlerin den Ablauf und die Ordnung der Bildfolgen je nach ihrer Präsentation ändert und verschiebt und so die Erwartung auf lineare Entwicklungsabläufe von vornherein ins Leere laufen läßt.

Als eine aufeinander bezogene Gruppe von Aufnahmen lassen sich Szenen ausmachen, die eine junge weiße Frau und ihr dunkelhäutiges Baby, sowie zwei Nonnen betreffen. Ebenfalls in einem gewissen inneren und personellen Zusammenhang stehen die Auto- und Straßenbilder mit dem auf allen Vieren kriechenden Mann und den Schrott-Autosequenzen, zu denen möglicherweise auch die Ringkampf-Szenen zu rechnen wären. Daneben aber bleiben Bilder, die sich keinem der beiden Komplexe zuordnen lassen: In einer Senke einer trostlosen Steppenlandschaft liegt eine Gestalt rücklings auf dem Boden und

streckt die Arme gen Himmel. Auf einem well-
blechbaracken-gesäumten Weg stehen Menschen
in Schlafanzügen und weißen Bademänteln, die
unverwandt in unsere Richtung schauen. Neben
einer Brücken-Unterführung spielt ein dunkel-
häutiges Mädchen in einer Krankenschwestern-
tracht mit Wurfringen.

Die Raffinesse all dieser Bilder liegt darin, daß
sie uns einen erzählerischen Zusammenhalt ver-
sprechen, ohne ihn einzulösen, aber auch ohne
ihn völlig zu enttäuschen. Tracey Moffatt arbeitet
mit einem hohen Maß an suggestiver Verführung,
bringt ihre Bilder über Motivwahl und Kompo-
sitionsdramaturgie auf eine hohe Betriebstempe-
ratur und entläßt sie dann in einen schwebenden
Zustand, in ein Zwischenreich perfekt ausbalan-
cierter Mehrdeutigkeit. Diese Ambivalenz funk-
tioniert auch deswegen so gut, weil die Bilder alle
mehrfach besetzt sind. Sie artikulieren sich als
Extrapolationen eines kollektiven Bildervorrats, in
dem autobiografische, werbe- und trivialästheti-
sche, filmische und kunsthistorische Anregungen
zu hybriden Bildbastarden verschmolzen werden,
die gerade, weil sie an alles erinnern, eine eindeu-
tige Lesbarkeit konsequent verweigern.

In nahezu allen Foto-Folgen, besonders aber
in »Up in the Sky« ist eine filmische Perspektive
im Umgang mit Bildern spürbar. Fast scheint es
so, als hungerten die Aufnahmen danach, in den
bewegten, kinematografischen Zusammenhang
überführt zu werden, als führten sie hier nur eine

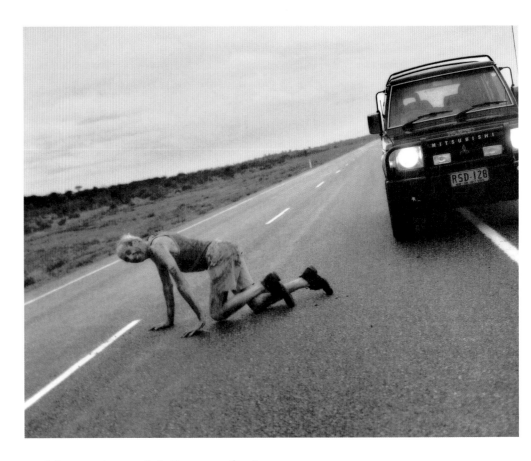

Schattenexistenz, als Stellvertreter für das, was
sich aus ihnen entwickeln könnte. Aber der erste
Eindruck täuscht. In Wirklichkeit – und das ver-
bindet sie mit den »Untitled Film Stills« von
Cindy Sherman – simulieren sie nur eine schein-
bare Abhängigkeit vom Film, hinter der sich ihre
fotografische Verfasstheit eigenständig behauptet.
Dies sind eben keine Film-Stills, sondern reine,

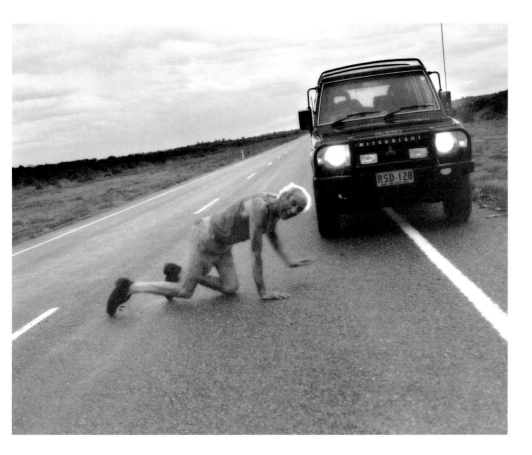

Platz einen erbitterten Ringkampf miteinander führen, zeigt uns Tracey Moffatt als kontinuierlichen Ablauf, aber selbst hier, wo die filmische Dimension mit Händen zu greifen ist, bleiben die Bilder völlig einzeln für sich stehende fotografische Kompositionen. Sowenig wir über den Grund für die körperliche Auseinandersetzung erfahren, sowenig gibt es in den vier Aufnahmen eine Entwicklung oder Entscheidung innerhalb des Kampfes.

Was wir sehen, ist formal die an anderer Stelle schon skizzierte Verschränkung von größtmöglicher äußerer Bewegung bei gleichzeitigem völligen Stillstand. Strukturell erleben wir die Vorführung einer Suche nach dem, was Bilder, zumindest im Sinne Tracey Moffatts, eigentlich sein sollten: Spuren des Unsagbaren im Gewand narrativer Gegenständlichkeit. Anders gesagt: Alles, was diese Bildfolge zu erzählen scheint, ist in Wirklichkeit eine Methode der Verschließung nach innen. Das Spektrum der Deutungs- und Assoziationsmöglichkeiten, das sie in sich birgt, ist gerade deshalb so breit, weil es sich nach außen nur scheinbar mitteilt. Der eigentliche Entwicklungsprozess dieser Bilder verläuft nach innen. Sie informieren ihre eigene somnambule Tiefe. Das Versprechen auf konsistente Information, die die Bildoberflächen zu liefern scheinen, ist nichts als Illusion: eine flirrende, flimmernde Fata Morgana – so leer und ungreifbar, wie die australische Steppe.

nur in diesem Medium funktionierende Fotografien. Daß wir hinter und zwischen ihnen einen Film ablaufen zu sehen meinen, ist ein Hinweis auf die Macht der fotografischen Inszenierung, die uns dazu ermuntert, Fäden zu spinnen und Verbindungen herzustellen, wo in Wahrheit nur Lücken und Leere zu finden sind. Vier Bilder von zwei Männern, die auf einem staubigen, kahlen

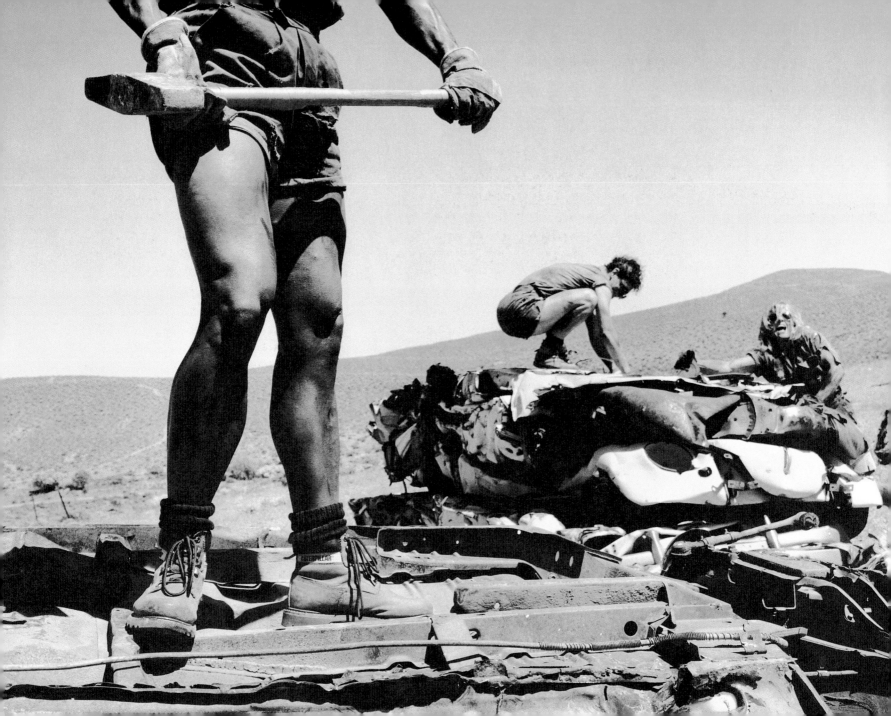

SOMEWHERE

Stephan Berg

At the end of the 1989 photo series *Something More*, which earned Tracey Moffatt international acclaim practically overnight in the early nineties, we find an image that might be read as a metaphor for a substantial portion of the work of this Australian artist. The black-and-white photo shows the "heroine" of the series lying face down on the centre line of a gravel-covered road which runs as a painted stripe into the background (which is actually a wall). A sign lying on the ground lets us know that the spot is located three hundred miles from Brisbane. The appearance of the prostrate woman – shoeless, her skirt hiked up and her panties exposed – suggests the possibility of a crime to which she has fallen victim. But we cannot be sure. The pictorial elements are arranged in such a way that we are compelled to look for a narrative context; yet we do not find it, as the constellation is articulated so broadly that it permits only readings at multiple levels of meaning. Accordingly, the photo offers few clear, identifiable points of reference with regard to the specific location and the time at which the action takes place. The interplay of theatrical elements and real one, which nonetheless have an arranged look, shifts the situation – the road sign notwithstanding – into the realm of a structure devoid of location and time beyond the boundaries of all reality and fiction. And the fact that Tracey Moffatt, who plays the part of the woman in the series, is from Brisbane herself does not change that in the least. Indeed, the playful inclusion of autobiographical elements itself underscores the futility of any attempt to interpret them autobiographically. Tracey Moffatt can hardly be identified with the "heroine" of the photo series, nor can we read Brisbane against this background as the real city. The deictic reference to that place is meaningful only in a dramaturgical sense. It describes a distance which the woman lying on the road cannot possibly travel in her condition. This allusion to the Australian city, as distant for the protagonist as the moon, underscores the detachment and distance that characterises the situation: no place, nowhere – only the strip of road with its centre-stripe seam that runs from the void of the foreground into the void of the upper edge of the photo.

With the exception of *Scarred for Life*, we find this sense of nowhere that oscillates between the surreal and the logic of dream in all of Tracey Moffatt's works, including *laudanum*, and it is particularly apparent in the twenty-five-part photo series *Up in the Sky*, completed in 1997. It has been noted by several authors that Tracey Moffatt's photographs "appear to revolve above all around an interplay of conflicts, whereby the human body itself is the subject of conflict".[1] Just as important, however, is the observation that, although these antagonisms are given a

1
John Yau, "Wettkampf", in *Tracey Moffatt*, exh. cat., Kunsthalle Wien et al., edited by Martin Hentschel, Gerald Matt (Cantz Verlag; Ostildern-Ruit, 1998), p.12.

Up in the Sky, 1997

spatial context (with the exception of *Guapa*, in which the action takes place in the milky white studio void), they actually never acquire the focus of a concrete topography. Even in *Up in the Sky*, the photos printed on ochre and steel-blue coloured paper only seem to contain reliable clues as to the location of the action. Barracks-style buildings of corrugated sheet metal, part of a concrete bridge underpass, details from an interior, trees and power lines contribute to the illusory sense of some kind of spatial framework in which the actors are placed but with to which they cannot really relate.

Although Tracey Moffatt uses no sets whatsoever in this series, the underlying reality of the Outback of the Australian plains does not appear as reality but instead as a staged surrogate. But as in *Something More*, the basis for this staging is a fundamental void of time and place, a *tabula rasa* bisected only by the white-lined strip of road which in turn offers no sign of hope that one could reach a destination on it. On the contrary, the motif of a jeep waiting at the roadside with its headlights burning and a tattered old man in a filthy undershirt and shorts crawling on his hands and knees across the road, first in one direction and then in the other, points to the shift away from a linear perception of space toward a form of vibrant standstill, as does the motif composed of men and women holding sledge hammers standing on a heap of totally demolished cars.

It is not difficult to find links between these particular photos and the first two *Mad Max* movies, films whose influence upon her work the artist openly acknowledges.[2] *Mad Max* is an apocalyptic parable from a world in which the fundamental principles of civilisation no longer apply, where cities and viable communities no longer exist – a world of endless roads on which apocalyptic, highly motorised gangs wage an embittered war for fuel. Petrol as fuel for propulsion is not only the motif that drives the film and thus provides self-reflective commentary on the medium; indeed the war over petrol is also a metaphor for the self-centred senselessness of the trips it makes possible, which always lead only from one void to the next. Thus despite its extreme surface dynamics, the film also speaks of an extreme inner standstill. It is the story of the transformation of the "good" cop Max into the fictional character Mad Max, who – clothed in leather from head to toe – trades in his conventional police car for a high-powered V-8 and, in symbolic unity with this super-tuned bachelor's machine, races into insanity, which he literally experiences in the flesh.

2
Cf. Interview with Tracey Moffatt by Gerald Matt, in *Tracey Moffatt*, op. cit., p. 12.

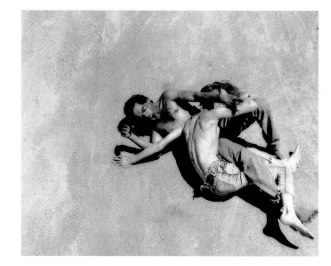

As mentioned above, *Up in the Sky* takes up several of the central aspects of this cinematic constellation, including even the destructive union of man and machine, which becomes evident in the image of male bodies joined with demolished cars, yet – by incorporating motifs of a different tone – it keeps the outcome in much greater suspense. This aspect of non-distinctiveness and structural ambiguity relates to the spatial fixation of the work but even more to its narrative approach. Unlike the preceding series, *Something More, Pet Thang, Guapa* or *laudanum*, a work completed in 1998, Tracey Moffatt combines several totally unrelated plot sequences in *Up in the Sky*. Actually, the term "plot sequences" is misleading, since what the artist offers is really a number of fragmentary elements, moments whose collective coherence is extraordinarily fragile, especially in view of the fact that she

changes the sequence and the order of the photo series for each presentation and thus frustrates the expectation of linear development from the outset.

Scenes showing a young white woman and her dark-skinned baby along with two nuns can be identified as parts of a group of related photos. Also characterised by a certain internal personnel logic are the car and road images with the man crawling on all fours and the junk-car sequences, to which the wrestling scenes could possibly be added as well. Aside from these, however, there are still pictures unaccounted for, images that can be assigned to neither of the two complexes: a human form lying on its back, its arms extended towards the sky in a gully on a barren plains landscape; people in pyjamas and white bathrobes standing on a road lined with corrugated sheet-metal barracks, staring aimlessly in our direction;

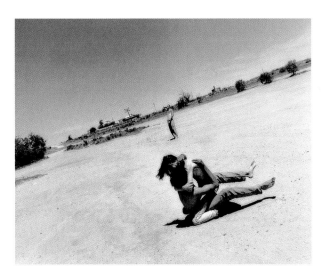

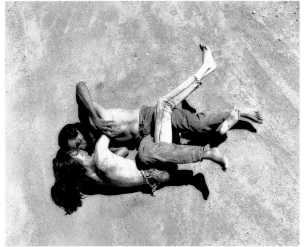

Up in the Sky, 1997

37

a young, dark-skinned girl in a nurse's uniform playing ring-toss beside a bridge underpass.

The ingenious quality of these photos consists in the fact that they promise us narrative cohesiveness without keeping that promise yet still do not disappoint us completely in our expectation. Tracey Moffatt employs a large measure of seductive suggestion, bringing her photos up to a high operating temperature through her selection of motifs and the dramaturgy of her composition and then releasing them into a state of suspension, an in-between world of perfectly balanced ambiguity. And one of the reasons why this ambivalence works so well is that all of the pictures harbour multiple meanings. They express themselves as extrapolations of a collective inventory of images in which inspirations from autobiography, advertising, trivial-aesthetics, the cinema and art history are melted down to form hybrid, bastardised pictures which stubbornly resist clear interpretation simply because they remind us of everything.

In nearly all of the photo series, and most notably in Up in the Sky, we sense the workings of a cinematic perspective in the artist's handling of images. It almost seems as if the photos hungered to be transposed into a moving, cinematographic context, as if they were living only a shadow existence here as mere representatives of what they could otherwise become. Yet the first impression is misleading. In reality – and they share this quality with Cindy Crawford's Untitled Film Stills – they only simulate an apparent dependence upon film. It is a disguise behind which their photographic versions assert their independence. These are not film stills at all but pure photographs which work only in this medium. The fact that we think we see a movie running behind and amongst them is simply a reminder of the great power of Moffatt's photographic stagecrafting, which encourages us to spin threads and forge links where there is actually nothing but gaps and emptiness. Tracey Moffatt shows us four photos of two men involved in an bitterly-fought wrestling match on a dusty, barren spot as a continuous sequence, yet even here, where the cinematic dimension is so palpably evident, the pictures remain completely independent, insular photographic compositions. We learn next to nothing about the reason for the physical combat, and the four photos offer no hint of the battle's development or outcome.

What we do see in a formal sense is the union of maximum external movement and complete standstill already sketched out above. Structurally speaking, we witness the demonstration of a quest for what photographs, at least in Tracey Moffatt's view, are really meant to be: evidence of the unspeakable in the cloak of narrative objectivity. Or to put it differently, everything this sequence of images seems to be telling us is actually a method of achieving introversion. The range of possibilities for interpretation and association it encompasses is so broad for the very reason that it only appears to express itself externally. The real dynamics of these photos are an inward-directed process. They inform their own somnambulant depths. The promise of consistent information seemingly voiced by the surfaces of the photos is nothing but illusion: a flickering, shimmering mirage – as empty and chimerical as the Australian plains.

Up in the Sky, 1997

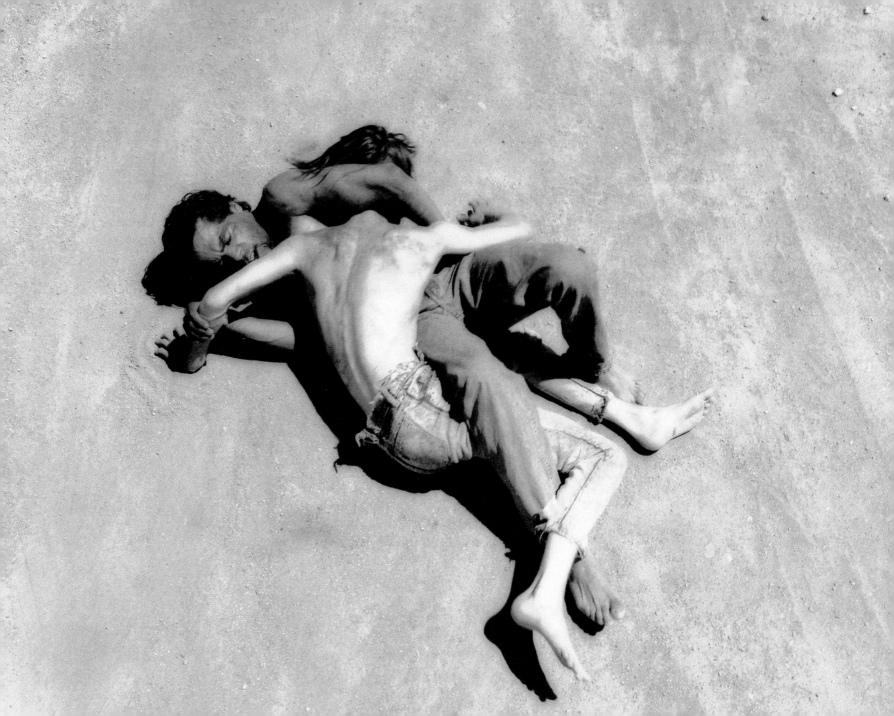

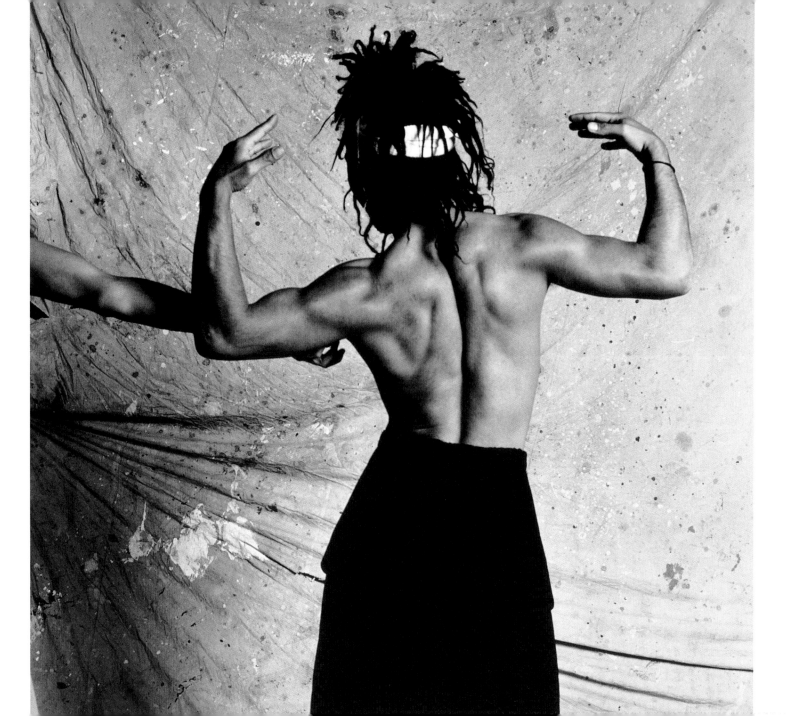

TRACEY MOFFATT UND DIE AUSTRALISCHE FOTOGRAFIE

Alexander Tolnay

Es ist ein bemerkenswertes Zusammentreffen der historischen Ereignisse, daß zur gleichen Zeit, als die Fotografie in Europa erfunden wurde – also in den dreißiger Jahren des 19. Jahrhunderts – die freiwillige Besiedlung Australiens begann, das bis dahin lediglich als koloniales Territorium für britische Sträflinge diente. Zugleich setzte die brutale Dezimierung der Ureinwohner des Kontinents ein. Zwar haben diese Tatsachen ursächlich nichts miteinander zu tun, aber ihre Koinzidenz verblüfft im Zusammenhang dieses Beitrags, in dem es um die Positionierung von Tracey Moffatts Fotokunst im australischen Kontext geht, und weil die Künstlerin – obwohl als Adoptivtochter in einer weißen Familie aufgewachsen – von den Ureinwohnern Australiens, den Aborigines, abstammt.

Die australische Fotogeschichte, die mit europäischen Fotografen aus der Reihe der vorhin zitierten Frühsiedler begann und in Alfred Bock (1835–1920), den ersten, bereits in Australien geborenen Vertreter fand, blieb für die Rezeption außerhalb des Landes mit wenigen Ausnahmen (wie beispielsweise die Teilnahme von David Moore und Laurence Le Guay in Edward Steichens New Yorker MOMA-Ausstellung »The Family of Man«, 1955) bis zu den siebziger Jahren nahezu unbekannt. Erst der Auftritt einer neuen Generation von Künstlern vor rund dreißig Jahren sorgte dann für einen unerwarteten Aufschwung auf dem Gebiet der technischen Medien Fotografie, Film und Video. Diese Künstlergeneration, deren bekanntester Repräsentant im Bereich der Fotografie der 1955 in Melbourne geborene Bill Henson ist, entstammte den »post-war-baby-boom«-Jahrgängen, die unter wohlgeordneten materiellen Verhältnissen und in einer technisch hoch entwickelten und urbanisierten Gesellschaft aufwuchsen. Ihre natürliche Einstellung zu der »Massenware« Fotografie machte deren Einsatz für künstlerische Zwecke selbstverständlich.

Im Gegensatz zu den Vorgängern, die man geringschätzig als »photography illustrators« bezeichnete, verstand sich diese neue Fotografengeneration als autonome Künstler. Sie nahm Stellung gegen die weitverbreitete Praxis der kommerziellen Anwendung der Fotografie und opponierte gegen die sie umgebende Konsumhaltung. Das war auch die Zeit der politischen Proteste gegen die australische Beteiligung am Vietnam-

Some Lads, 1986/98

41

krieg, die neue alternative Kulturkonzepte und Kunstformen hervorbrachte.

Ebenso fällt in diese Zeitperiode die schrittweise offizielle Anerkennung der Fotografie als Kunstform in Australien und ihre historische Aufarbeitung als Teil der Kunstgeschichte. 1972 wurde in der National Gallery of Victoria die erste Fotoabteilung mit einem eigenen, hierfür zuständigen Kurator eröffnet. Mit gesamtaustralischen Ambitionen, die sich aber nicht erfüllten, gründete man 1974 nach dem Muster des New Yorker International Centre for Photography in Sydney das Australian Centre for Photography. Es dauerte noch ein Jahrzehnt, bis diese Anfänge auf Bundesebene erweitert und 1982 eine eigenständige Fotosammlung in der National Gallery of Australia, Canberra, eingeweiht wurde. Parallel dazu etablierten sich einige private, von Fotografen geleitete Galerien, wie zum Beispiel The Photographer's Gallery and Workshop in Melbourne (1974), und es erschienen kritische Fotozeitschriften, wie die »WOPOP – Working Papers on Photography« (1977).

Was die Themen- und Stilfragen betrifft, herrschte auch in Australien eine für die Epoche charakteristische Heterogenität, und der amerikanische Einfluß, durch zahlreiche Publikationen und Ausstellungen gefördert, war verständlicherweise stark spürbar. Ähnlich wie in Europa und Amerika, drehte sich die Diskussion um Definitionsversuche in der Unterscheidung zwischen »Fotografie als Kunst« (photography as art) und »Kunst mit Fotografie« (artists using photography). Ende der siebziger Jahre wurde dann die Fotografie endgültig als gleichberechtigte Kunstform akzeptiert und institutionalisiert, d. h. gesammelt und ausgestellt, publiziert und an den Kunstakademien gelehrt.

Dieser Rückblick ist hilfreich für ein Verständnis der Situation, in der Tracey Moffatt ihren Werdegang als eine mit Fotografie arbeitende Künstlerin begann. 1960 geboren, gehört Moffatt, die ihr Studium am Queensland College of Art in Brisbane 1982 abschloß und anschließend nach Sydney zog, bereits zur zweiten Generation derjenigen Fotokünstler, die eine professionelle Ausbildung an Kunstakademien absolvierten und die Fotografie mit Selbstverständnis in die künstlerische Arbeit integrierten. Zwar erzählt sie augenzwinkernd in einem Interview, daß die Neigung zu Fotografie und Film eigentlich nur an ihrer Faulheit liege (und weil sie eine miserable Malerin sei), dennoch ist ihre Begeisterung für diese Medien in Wahrheit in der Sechziger-Jahre-Kindheit und Siebziger-Jahre-Jugend begründet, die sie in einem australischen Arbeitervorort verbrachte, wo sie mit Comic-, Film- und Fernsehbildern aufwuchs.

Bereits vor ihr entwickelten einige australische Künstlerinnen – wie Micky Allan, Ruth Madison oder die etwas jüngere Robyn Stacey – eine aus Zeitschriften und Filmen entlehnte Bildsprache,

die auf der einen Seite zu einer Revitalisierung der Dokumentarfotografie der sechziger Jahre führte, andererseits bereits ironische Kommentare zu gesellschaftlichen Klischees enthielt oder feministische und ethnische Fragestellungen thematisierte. Das Auftauchen ethnischer Künstler in den achtziger Jahren, die sowohl von Einwanderern als auch von Ureinwohnern abstammten, spiegelt die demografischen und sozialen Veränderungen der vorangegangenen Jahrzehnte in Australien wider. Tracey Moffatt gehört zu jenen Künstlern, die sich angesichts ihres unterschiedlichen ethnischen und kulturellen Hintergrundes Mitte der achtziger Jahre mehr oder weniger subtil dem »multikulturellen Dilemma« mit Mitteln der Fotografie zuwandten. Die im Libanon gebürtige Seham Abi-Elias oder die Badtjala Aborigine-Künstlerin Fiona Foley (beide 1964 geboren) sind hierfür mit ihren nicht der gewohnten Stereotypie entsprechenden Portraits markante Beispiele.

Eine der frühen Arbeiten Tracey Moffatts, »Some Lads« (1986), ist eine solche Portrait-Serie mit schwarzen Tänzern, die zwar die europäischen völkerkundlichen Fotokonventionen des 19. Jahrhunderts übernimmt, aber durch die selbstbewußten Haltungen der Akteure die herkömmliche Intention unterläuft. Diese Methode des »Gegen-den-Strich-Bürstens« bleibt auch in Moffatts folgenden Werkserien ihre vorherrschende Arbeitsweise.

Gruppenbewußtsein, Multikulturalität und kulturelle Identitätsbildung waren wichtige Themen der achtziger Jahre in Australien. Dementsprechend nahm die Fotografie an dieser öffentlichen Diskussion teil, die auch auf Moffatts Arbeit einen bedeutenden Einfluß hatte. Neben dem gleichzeitigen Wiederaufblühen der Malerei wurde die Fotografie eine Kunstäußerung von äquivalentem Rang in der kritischen Bilddiagnose und in der Auseinandersetzung mit der janusköpfigen Rolle von Wirklichkeitsabbildung und Fiktion.

Ende der achtziger Jahre bewegte sich die Fotografie sogar ins Zentrum des Interesses der australischen Kunstwelt, da sie eine der wichtigsten Merkmale des postmodernen Zeitalters besaß: die Reproduzierbarkeit. Ihr bisheriges Handikap wurde ihr ironischerweise zum Vorteil: durch die Vervielfältigungstechnologie konnte sie als Mittel von Aneignung (Appropriation) und assimilativer Einverleibung verwendet und als solches trotzdem als Trägerin von individuellen Interpretationen eingesetzt werden. Im Gegensatz zu früher, als Australien noch darunter litt, daß durch die große Entfernung von anderen Kontinenten alles, was dort kulturell geschah, nur als indirekte Abbildung, als fotografische Reproduktion zur Verfügung stand, wurde nun das Ausschlachten des Sekundärmaterials um so freudiger ausgekostet.

Mit dem Einzug der digitalen Techniken in die Fotografie der neunziger Jahre wurde dann der

Schritt von Frank Stellas WYSIWYS (What You See Is What You See) zu Bill Gates WYSIWYG (What You See Is What You Get) endgültig vollzogen. Robyn Staceys inszenierte Fotografie der achtziger Jahre weicht der digitalen Verarbeitung: viele Zeitgenössinnen Moffatts – wie Jane Eisenmann, Rosemarie Laing oder Patricia Piccinini – bedienen sich der Computertechnologie zu ihrer Bildfindung.

Nicht wenige australische Fotokünstlerinnen – darunter Anne Zahalka, Kaye Shumack und Tracey Moffatt selbst – benutzen heute die weitverbreiteten Bilder der Massenmedien als Ausgangspunkt ihrer Arbeit und vertrauen beim Publikum auf die gemeinsamen Vorkenntnisse und den gleichen Informationsstand durch Film, Fernsehen und Werbung. Mittels verschiedener Strategien – wie Umstellung, Neubesetzung oder Sequenzenbildung – erreichen sie jedoch eine Neuinterpretation oder eine Infragestellung der Bezugsquellen. Die Kompositionsmethode der Bildreihung, die in den siebziger Jahren bei Jon Rhodes in der Arbeit »Just another Sunrise? – The Impact of Bauxite Mining of An Aboriginal Community« (1974/75) noch ausschließlich dem Zweck der dokumentarischen Anordnung diente, wird bei Tracey Moffatts Fotoarbeiten »Something More« (1989), »Guapa« (1995) und »Up In The Sky« (1997) Vehikel für eine Art filmische Erzählung. Ohnehin läßt sich beobachten, daß Moffatt die beiden Medien Film und Fotografie wechselwir-

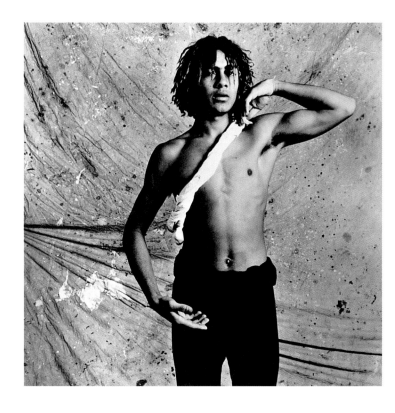

kend anwendet. Genauso wie ihre Fotoserien von der Dramaturgie des Kinos Gebrauch machen, lösen sich ihre Filme bei näherer Betrachtung in aneinandergereihte Fotoaufnahmen auf. Dementsprechend ließ sie sich auf die Frage, ob sie nun Fotografin oder Filmemacherin sei, nicht festlegen und gab die Antwort, daß sie sich als »image maker« bezeichne.

Die Verarbeitung der Kindheits- und Jugenderlebnisse ist, wie eingangs erwähnt, nicht nur für

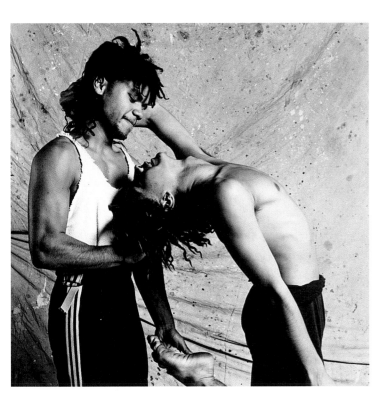

Tracey Moffatt charakteristisch, sondern für viele Fotokünstler ihrer Generation. Das WYSIWYG der Computerästhetik verwandelt sich bei ihnen zu einem WYSIWYR (What You See Is What You Remember). Die Erinnerung an die individuelle Lebensgeschichte geht mit der Rückbesinnung auf das historische Erwachsenwerden des Landes einher. Die kulturelle Verortung findet gleichzeitig mit der Klärung des eigenen geistigen Standortes statt.

Es war ein langer Weg von Alfred Bock, dem ersten Fotografen der noch jungen Kolonie, bis zu den internationalen Erfolgen der Schwarzaustralierin Tracey Moffatt, ein langer und mühsamer Weg der Emanzipation, der in der Geschichte der australischen Fotokunst symbolhaft für die gesamte historische Entwicklung des fünften Kontinents steht.

Some Lads, 1986/98

TRACEY MOFFATT AND AUSTRALIAN PHOTOGRAPHY

Alexander Tolnay

It is a remarkable coincidence of history that the very same years which witnessed the invention of photography in Europe – the 1830s – also marked the beginning of the stream of voluntary immigration to Australia, a land which had previously served as a penal colony under British colonial rule. We also note the initiation of the brutal process of subjugation and decimation the continent's native population during this same period. While there is no causal relationship linking these events, their coincidence does indeed astonish when viewed within the context of this attempt to identify Tracey Moffatt's position in Australian photography, as the artist – although adopted and raised by a white family – is a descendent of native Australians, the Aborigines.

The history of Australian photography, which began with the work of photographers from the ranks of the early immigrants mentioned above and hailed its first Australian-born representative in Alfred Bock (1835–1920), remained with few exceptions (such as the participation of David Moore and Laurence Le Guay in Edward Steichen's New York MOMA exhibition, "The Family of Man") a virtually unknown quantity beyond Australia's shores until the 1970s. It took the arrival of a new generation of artists some thirty years ago to trigger the unexpected surge of interest in the technical media of photography, film and video. This generation of artists, whose most noteworthy representative in the field of photography was Bill Henson of Melbourne, born in 1955, emerged from the post-war baby boom years as the products of well-ordered economic circumstances and a highly technical, urbanised society. Having grown up with photography as a "mass-produced commodity", they quite naturally took its use in art as a given.

In contrast to their predecessors, looked upon somewhat scornfully as "photography illustrators", photographers of the new generation saw themselves as independent artists. They objected to the widespread practice of commercial photography and opposed the consumption-oriented ideology it represented. These were also the years of political protest against Australian involvement in the Vietnam War and of the birth of new, alternative concepts of culture and forms of art.

This period also witnessed gradual progress towards official acceptance of photography as an art form and first efforts devoted to study of the medium as part of art history. The National Gallery of Victoria opened its first photography section with its own curator in 1972. With an eye to pan-Australian ambitions (which were never achieved, however), the Australian Centre for Photography was established on the model of the New York International

Center for Photography in 1974. It was not until ten years later that these first steps were expanded at the national level with the founding of an independent photo collection at the Australian National Gallery in Canberra. In a parallel development, a number of private galleries were established under the direction of photographers, among them The Photographer's Gallery and Workshop in Melbourne (1974). Such critical journals on photography as *WOPOP – Working Papers on Photography* (1977) also made their debut during the decade.

With regard to matters of subject and style, we find in Australia much the same heterogeneity that characterised the epoch as a whole, and the American influence, supported by numerous publications and exhibitions, is understandably impossible to overlook. As was true in Europe and America as well, discussion revolved around issues of definition relating to the distinction between photography as art and artists using photography. By the late 1970s, photography had finally achieved recognition as a genuine art form in its own right and was becoming institutionalised – that is, collected, exhibited, published and taught at schools of art.

This brief retrospective glance is helpful to us in our efforts to comprehend the situation in which Tracey Moffatt began her career as an artist who uses photography. Born in 1960, Moffatt, who completed her studies at the Queensland College of Art in Brisbane in 1982 before moving to Sydney, belongs to the second generation of photographers educated at art schools, artists who took the use of photography in their art more or less for granted. Despite her tongue-in-cheek comment in an interview that her leanings towards photography and film are simply the product of her own laziness (and the fact that she is a miserable painter), the roots of her enthusiasm for this medium actually go back to her childhood in the sixties and her youth during the seventies, years in which she lived in a working-class Australian suburb and grew up on a diet of comics, movie and television images.

Several women artists before her – including Micky Allan, Ruth Madison and the somewhat younger Robyn Stacey – had already developed a visual vocabulary adapted from magazines and movies, a language which led to a revitalisation of documentary photography during the seventies, on the one hand, and already contained ironic commentaries on societal clichés or dealt with feminist and ethnic issues, on the other. The emergence of ethnic artists – descendants of immigrants as well as Aborigines – during the 1980s is a reflection of the demographic and social changes that had taken place in Australia during the preceding decades. Tracey Moffatt is one of many artists who, in response to their perceptions of their different ethnic and cultural backgrounds, turned their attention through photography in more or less subtle ways to the "multi-cultural dilemma". As portraitists who abandoned familiar stereotypes, Seham Abi-Elias, a native of Lebanon, and the Badtjala Aborigine artist Fiona Foley (both born in 1964) are among the most prominent representatives of this group.

One of Tracey Moffat's first works, entitled *Some Lads* (1986), is just such a portrait series featuring black dancers. While it adopts the photographic conventions of European ethnology, the self-assured attitudes of the perform-

ers subvert its traditional intent at the same time. This technique of "rubbing against the grain" was to remain the predominant working approach in Moffatt's later series as well.

Group consciousness, multi-culturality and the development of cultural identity were important issues in Australia during the 1980s. Accordingly, photography took part in the public discussion, which in turn exerted a significant influence upon Moffatt's work. While painting was experiencing a revival of its own, photography also assumed an equally important position as a means of artistic expression in the critical diagnosis of visual images and in attempts to come to grips with the Janus-headed duality of reality and fiction in art.

In the late 1980s photography actually shifted into the centre of interest in the Australian art world, as it boasted one of the features regarded as most important in the post-modern era: reproducibility. Ironically, what had once been regarded as its handicap was now perceived as its advantage. With the aid of reproduction technology, photography could be used as a means of appropriation and assimilative incorporation, yet it could also serve as a medium for individual interpretations. In contrast to earlier times, when Australia laboured under the disadvantage of its great distance from the other continents and found access to the worlds of foreign culture only in the form of indirect images, of photographic reproductions, the exploitation of such secondary material was now pursued with great joy and vigour.

The emergence of digital techniques in photography during the 1990s finally closed the gap between Frank Stella's WYSIWYS (What you see is what you see) and Bill Gates' WYSIWYG (What you see is what you get). Robyn Stacey's staged photography of the 1980s has given way to digital image processing. Many of Moffatt's contemporaries – including Jane Eisenmann, Rosemarie Laing and Patricia Piccinini – make use of computer technology in their photographic work.

More than a few Australian photo artists – among them Anne Zahalka, Kaye Shumack and Tracey Moffatt herself – now use the widely disseminated images of the mass media as a starting point in their work, relying upon knowledge and information shared with their viewers on the basis of well-known films, television shows, commercials and ads. Using a number of different strategies, however – including adaptation, recasting and sequencing – they develop new interpretations or critical approaches to these sources. The method of composing with sequences, a technique employed by Jon Rhodes exclusively for documentary purposes in his *Just another Sunrise? – The Impact of Bauxite Mining on an Aboriginal Community* (1974/75) during the 1970s, becomes a vehicle for a kind of cinematic narrative in Tracey Moffat's photo series *Something More* (1989), *Guapa* (1995) and *Up in the Sky* (1997). Indeed, we observe that Moffatt often makes use of the interaction between the media of film and photography. Just as her photo series draw upon the dramaturgy of the cinema, her films dissolve upon closer inspection into arrangements of discreet photographic images. Predictably, she refuses to be pinned down when asked whether she is a photographer or a film maker, answering simply that she calls herself an "image maker".

As mentioned above, the deliberate processing of experiences from childhood and adolescence is characteristic not only of Tracey Moffatt but of many photo artists of her generation. In their hands, the WYSIWYG of computer aesthetics is transformed into WYSIWYR (What you see is what you remember). The process of recalling one's own life history goes hand in hand with the illumination of the country's progress towards adulthood. The exploration of a cultural position takes place in synchrony with the clarification of one's own intellectual and spiritual location.

The road from Alfred Bock, the first photographer of the still-young colony, to the international successes of the Australian Aborigine Tracey Moffatt, has been long – a long, tortuous road to emancipation in the history of Australian photography that also symbolises the history of the fifth continent.

Some Lads, 1986/98

LAUDANUM 1998

"Keep me rather in this cage, and feed me sparingly, if you dare. Anything that brings
me closer to illness and the edge of death makes me more faithful. It is only when you make
me suffer that I feel safe and secure. You should never have agreed to be god for me if you
were afraid to assume the duties of a god, and we all know that they are not as tender as all
that. You have already seen me cry. Now you must learn to relish my tears."

Jean Paulhan, 'Happiness in Slavery' preface to Pauline Reage, 'Story of O' (1954)

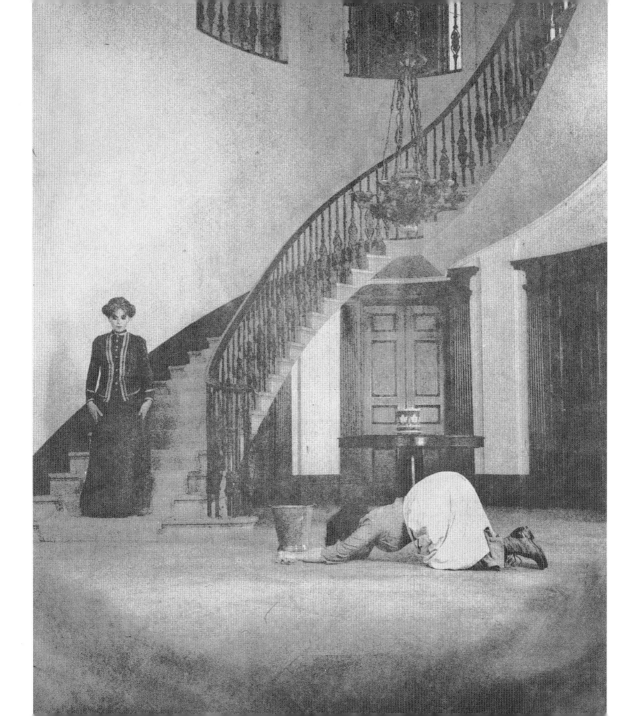

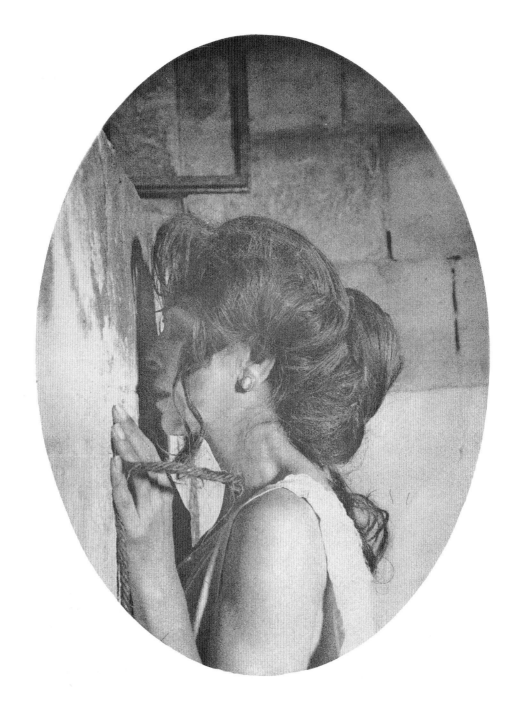

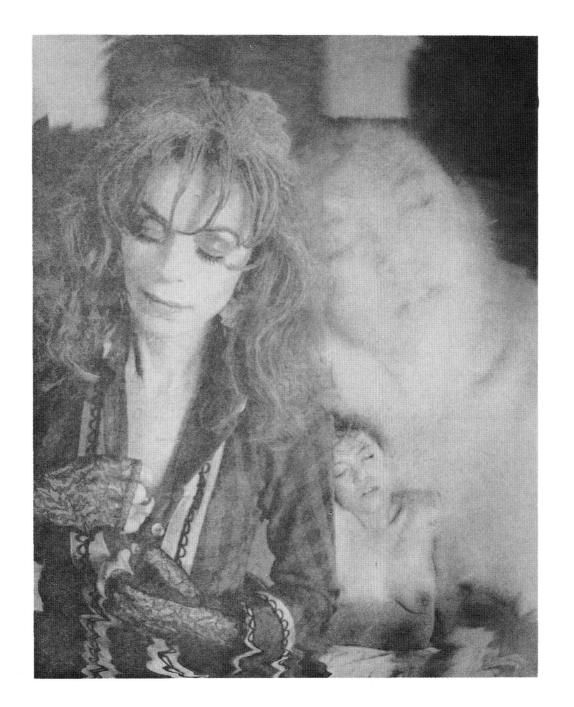

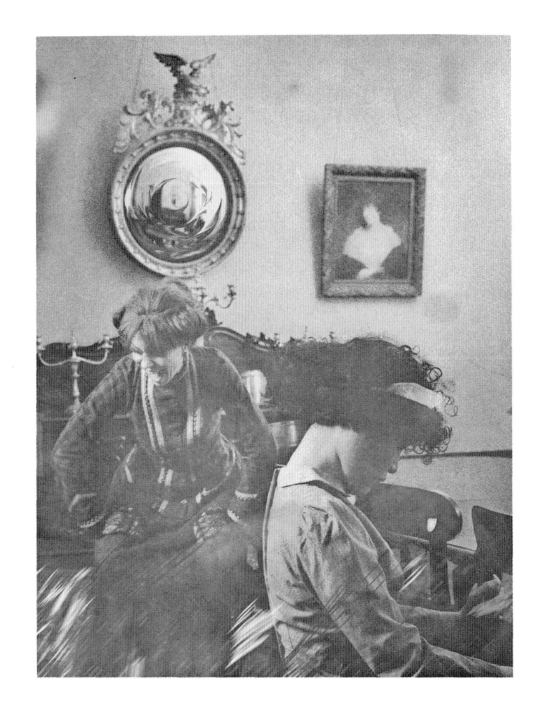

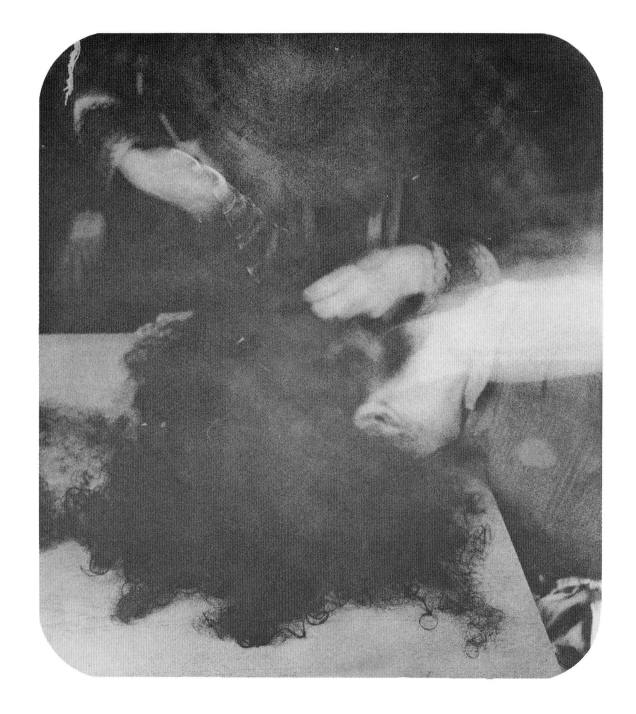

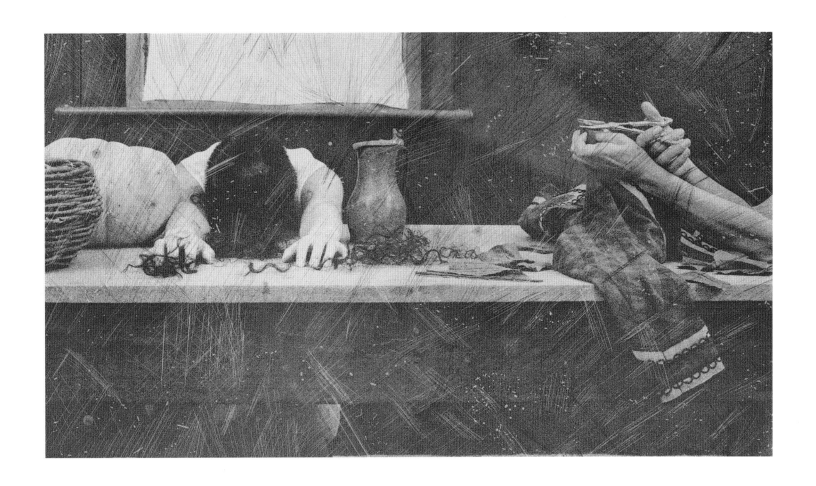

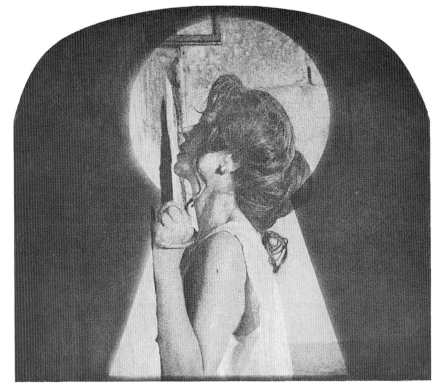

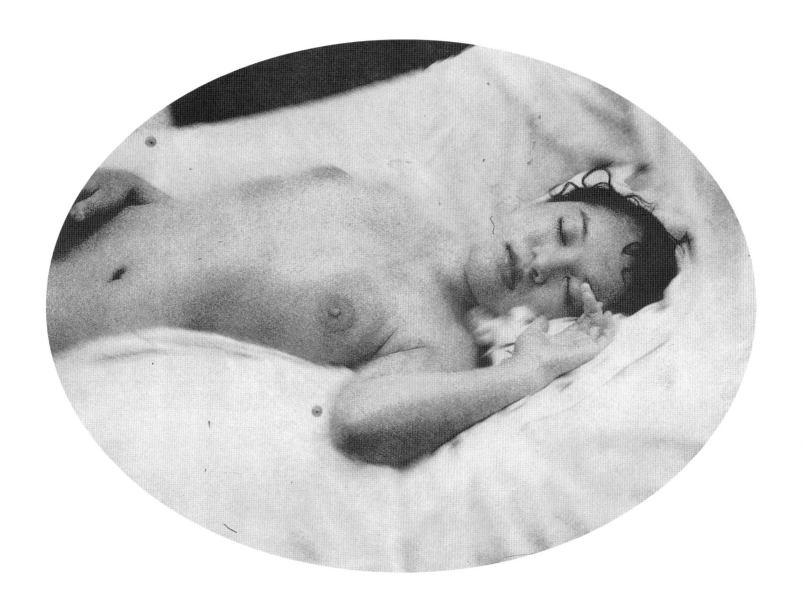

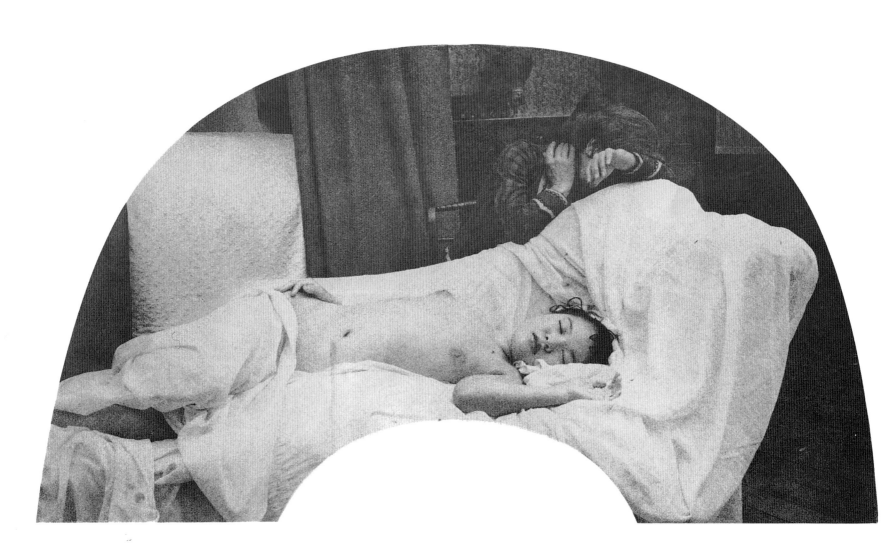

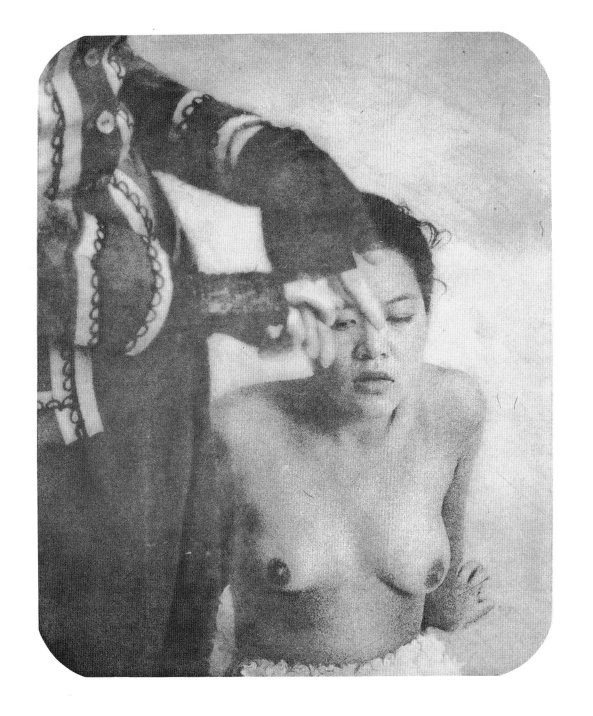

 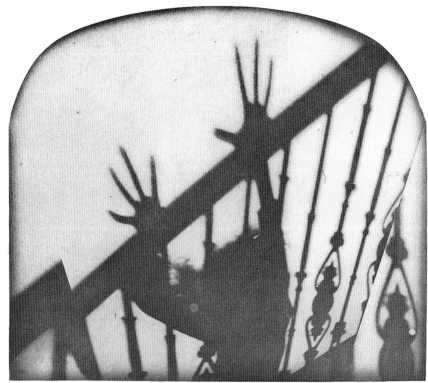

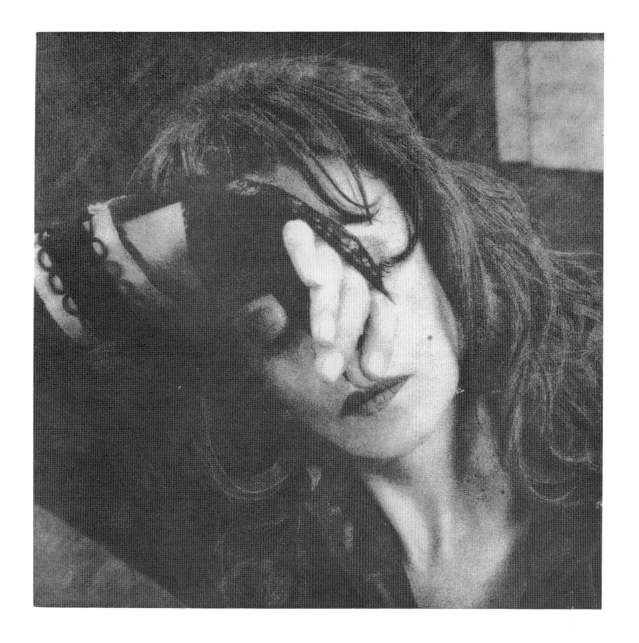

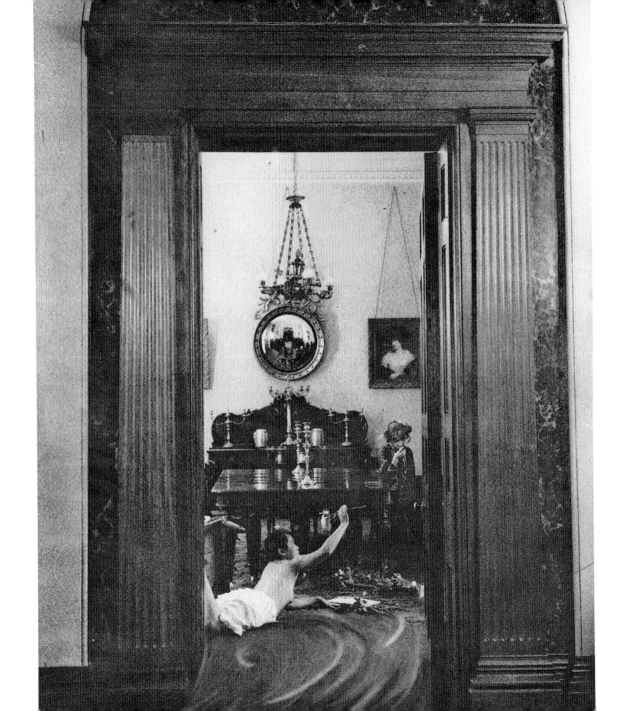

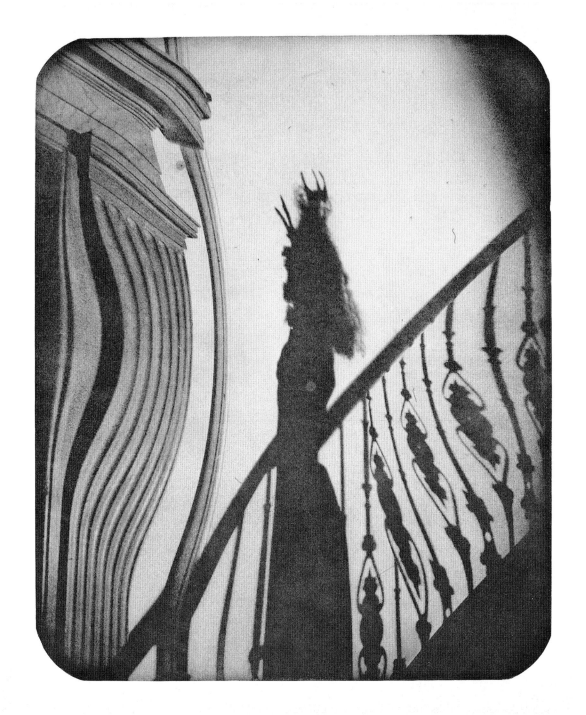

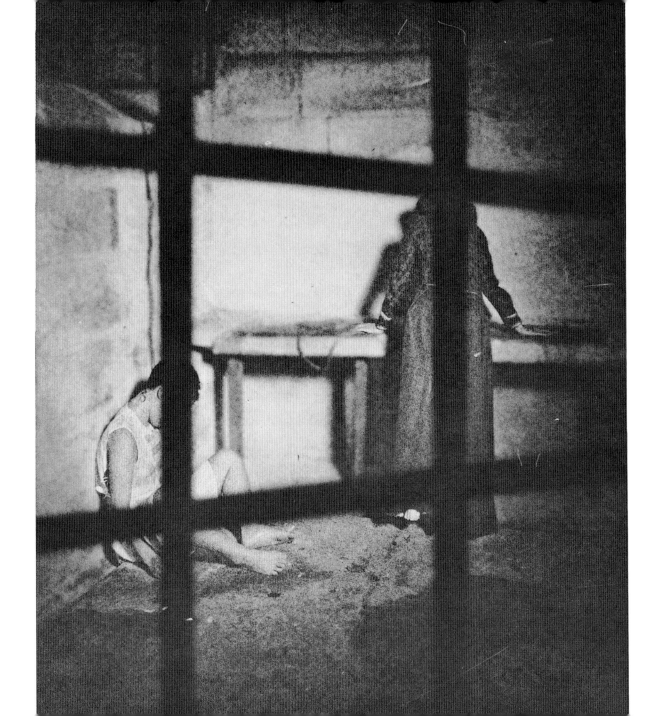

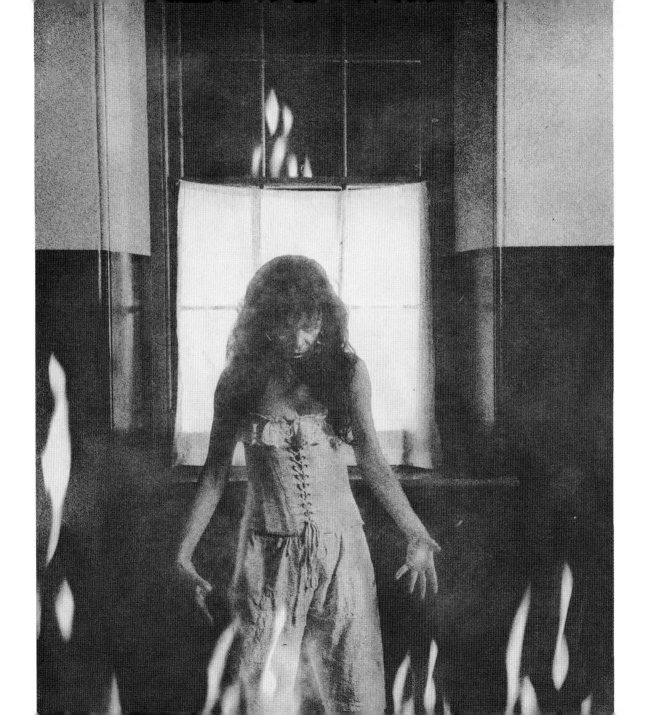

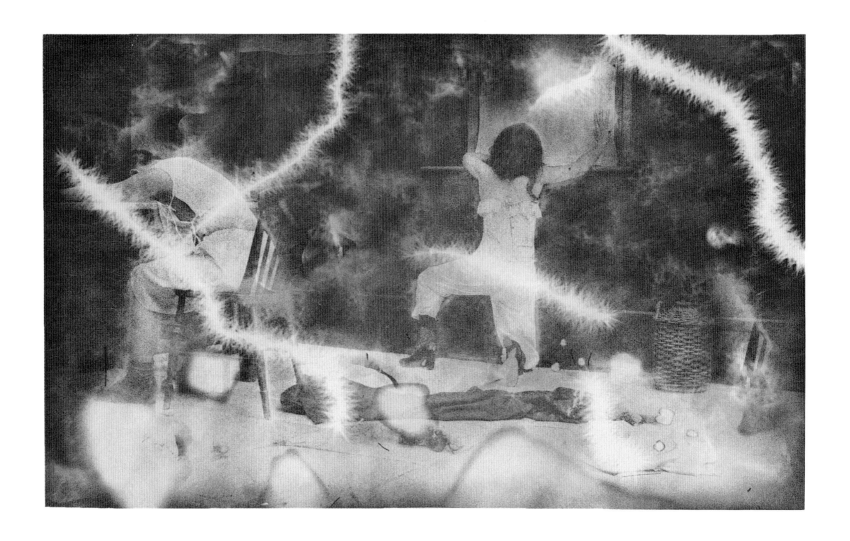

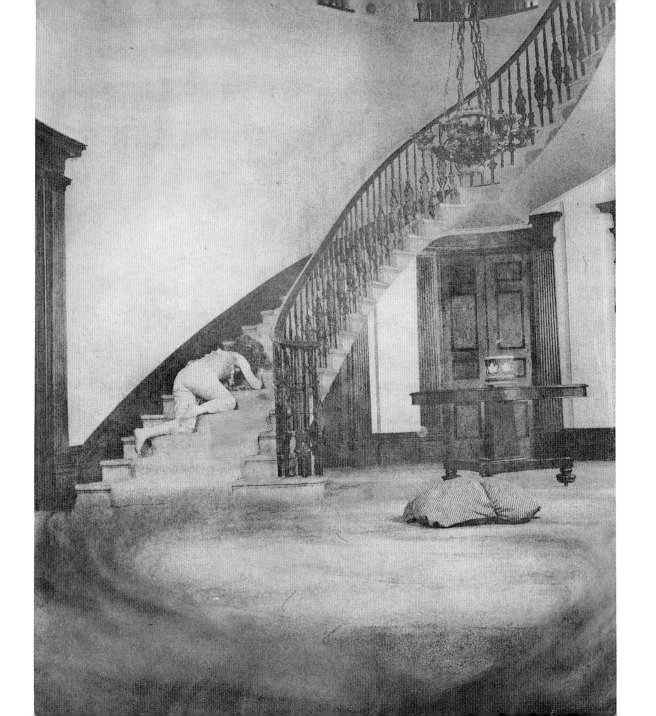

BILDSERIEN / PICTURE SERIES

Something More, 1989
6 Cibachrome und 3 Schwarzweiß-Fotografien/
black-and-white photographies
je ca.100 x 130 cm
Privatbesitz
Abb.S. / Ill. p. 8,10, 11, 28, 31

Pet Thang, 1991
6 Farbfotografien / coloured photographies
je ca.110 x 80 cm
Ulmer Museum, Ulm
Abb.S. / Ill. p. 16, 17, 18

Scarred for Life, 1994
9 Offsetprints:
Wizard of Oz, 1956; Birth Certificate, 1962;
Charm Alone, 1965; Heart Attack, 1970;
Doll Birth, 1972; Useless, 1974; Mother's Day,
1975; Job Hunt, 1976; Telecam Guys, 1977
je 80 x 60 cm
Privatbesitz
Abb.S. / Ill. p. 21

Guapa, 1995
10 Fotografien / photographies
je ca.80 x 110 cm
L.A.Galerie, Frankfurt a.M.
Abb.S. / Ill. p. 22, 23, 24, 25

Up in the Sky, 1997
25 Offsetprints
je 62 x 76 cm
L.A.Galerie, Frankfurt a.M.
Abb.S. / Ill. p. 26, 27, 32, 33, 34, 36, 37, 39

Some Lads, 1986/98
5 Schwarzweiß-Fotos
black-and-white photographies
je ca.50 x 60 cm
L.A.Galerie, Frankfurt a.M.
Abb.S. / Ill. p. 40, 44, 45, 49

Backyard Series, 1998
3 Offsetprints
je ca.53 x 73 cm
L.A.Galerie, Frankfurt a.M.
Abb.S. / Ill. p. 13, 14

Laudanum, 1998
19 Fotogravüre / photo-engravings
je ca.57 x 76 cm
L.A.Galerie, Frankfurt a.M.
Abb.S. / Ill. p. 51–69

VIDEOS UND FILME / VIDEOS AND FILMS

Nice Colored Girls, 1987
16 Minuten Experimentalfilm
16 minute experimental film

Night Cries – A Rural Tragedy, 1989
17 Minuten Drama / 17 minute drama

Bedevil, 1993
90 Minuten Spielfilm / 90 minute feature drama

Heaven, 1997
28 Minuten Video / 28 minute video

Alle Rechte der Filmreproduktion/ courtesy of
Women Make Movies, New York

Geboren / Born 1960 in Brisbane, Australia.

1982 Abschluß am / graduates from Queensland College of Art, Brisbane, in Visual Communications.

Lebt und arbeitet
Lives and works in Sydney and New York City.

1999 Ulmer Museum, Ulm, Germany
Fundacio Caixa de Pensions, Barcelona, Spain
L. A. Galerie, Frankfurt
Rena Brandsten Gallery, San Francisco
Torch Gallery, Amsterdam
Lawing Gallery, Houston, Texas, USA
»Free Falling«, ICA, Boston
Paul Morris Gallery, New York
Roslyn Oxley 9 Gallery, Sydney, Australia
Fundacio la Caixa, Sala San Juan,
Barcelona, Spain
Centre National de la Photographie, Paris
Galerie Laage-Salomon, Paris

1998 Arnolfini, Bristol, UK
Kunsthalle Wien, Vienna, Austria
Württembergischer Kunstverein,
Stuttgart, Germany
AR/GE Kunst Galerie Museum,
Bozen/Bolzano, Italy
Magazin 4, Voralberger Kunstverein,
Bregenz, Austria
»Free Falling«, The Renaissance Society,
Chicago, USA
L. A. Galerie, Frankfurt, Germany
Roslyn Oxley 9 Gallery, Sydney, Australia
Victoria Miro Gallery, London, UK
Le case d'Arte, Milano, Italy
Monash University Gallery, Melbourne, Australia
Curtin University Gallery, Perth, Australia
Galleri Larsen, Stockholm, Sweden

1997 »Free Falling«, Dia Center for the Arts,
New York, USA
L. A. Galerie, Frankfurt, Germany
Galleri Faurschou, Copenhagen, Denmark
Galerie Andreas Weiss, Berlin, Germany
Fond Régional d'Art Contemporain, Dijon
Casino Luxembourg, Luxembourg
Tracey Moffatt, Films,
Musée d'Art Contemporain, Lyon

1995 Guapa (Goodlooking), Karyn Lovegrove
Gallery, Melbourne, Australia
Guapa (Goodlooking), Mori Gallery,
Sydney, Australia
Short Takes, ArtPace, San Antonio, Texas, USA

1994 Scarred For Life, Karyn Lovegrove Gallery,
Melbourne, Australia

1992 Pet Thang, Mori Gallery, Sydney, Australia
Centre for Contemporary Arts, Glasgow, UK

1989 Something More, Australian Centre for
Photography, Sydney,
toured through regional galleries in Australia

GRUPPENAUSSTELLUNGEN / GROUP EXHIBITIONS

1999 *Wohin kein Auge reicht,* Deichtorhallen, Hamburg

1999/98 *Das Versprechen der Photographie. Die Sammlung der DG Bank,* Hara Museum of Contemporary Art Tokyo, Kestner Gesellschaft Hannover, Centre National de la Photographie Paris, Akademie der Künste Berlin, Schirn Kunsthalle Frankfurt
Rosa für Jungs, Hellblau für Mädchen, Neue Gesellschaft für Bildende Kunst, Berlin
Présumés Innocents, Musée d'Art Contemporain, Bordeaux, France

1998 *Roteriros' x 7, XXVI Bienal de São Paulo,* Brazil
Portraits (Photo Works), Paul Morris Gallery, New York, USA
Fleeting Portraits, Neue Gesellschaft für Bildende Kunst, Berlin
Horizont, Brechthaus am Weißensee, Berlin
Der Mensch / The Human Being, Kunstverein Schloß Plön, North Germany
Life is a bitch, De Appel Foundation, Amsterdam
»Die Nerven enden an den Fingerspitzen«
Die Sammlung Wilhelm Schürmann, Kunsthaus Hamburg, Germany
Echolot. Ghada Amer, Ayse Erkmen, Fariba Hajamadi, Mona Hatoum, Gülsün Karamustafa, Kim Soo-Ja, Tracey Moffatt, Shirin Neshat, Qin Yufen, Museum Fridericianum, Kassel, Germany

4. Foto Triennale Esslingen, Esslingen, Germany
Musée Departemental d'Art Contemporain, Rochechouart, France
Family Viewing, The Museum of Contemporary Art, Los Angeles
Nature of Man, Lund Konsthall, Lund, Sweden
Museum van Heedendaagse Kunst, Gent, Belgium
Der Mensch (The Human Being), Kunstverein Schloß Plön, Germany
Artenergie-Art, Palazzo Corsini, Rom, Italy
Guiness Contemporary Art Show, Art Gallery of North South Wales, Australia

1997 *Site Santa Fe,* Santa Fe, New Mexico, USA
Biennale di Venezia, Venice, Italy
On Dialogue. Zeitgenössische australische Kunst, Haus am Waldsee, Berlin
Mathew Marks Gallery, New York, USA
Anthony Reynolds Gallery, London, UK
Printemps de Cahors, Paris, France
Steirischer Herbst '97, Graz, Austria
Campo 6 – The Spiral Village, Bonnefanten Museum, Maastricht, Holland
Subject to Representation, Gallery 101, Ottawa, Canada

1996 *Fundacao Bienal de Sao Paulo,* Sao Paulo, Brazil
Campo 6 – The Spiral Village, Museo d'Arte Moderna, Torino, Italy

Jurassic Technologies, 10th Biennale of Sydney, Sydney, Australia
Prospect 96, Schirn Kunsthalle, Frankfurt am Main, Germany
Short Stories, Altes Rathaus, Göttingen, Germany

1995 *Antipodean Currents*, The Guggenheim Museum Soho, New York, USA
Familiar Places, ICA, Boston, USA
'95 Kwangju Biennale, Kwangju, Korea
New Works 95.2, Art Pace, San Antonio, Texas, USA
Perspecta 95, Art Gallery of New South Wales, Sydney, Australia

1994 *Antipodean Currents*, The Kennedy Centre, Washington, USA
Power Works, Govett Brewster Gallery, New Plymouth, New Zealand
Eidetic Experiences, toured through regional galleries in Queensland, Australia

1993 *The Boundary Rider*, 9th Biennale of Sydney, Sydney, Australia
The Art Gallery of New South Wales, Sydney, Australia

1992 *Artist's Projects*, Adelaide Festival of Arts, Adelaide, Australia

1991 *From the Empire's End – Nine Australian Photographers*, Circulo de Bellas Artes, Madrid, Spain; The Works Gallery, University of New South Wales, Australia

1990 *Satellite Cultures*, New Museum of Contemporary Art, New York, USA
Twenty Contemporary Australian Photographers, National Gallery of Victoria

1988 *Shades of Light*, National Gallery of Australia, Canberra, Australia

1987 *Art and Aboriginality*, Aspex Gallery, Portsmouth, UK

1986 *Aboriginal & Islander Photographs*, Aboriginal Artists Gallery, Sydney, Australia

1984 *Pictures for Cities*, Artspace, Sydney, Australia

Art Gallery of South Australia, Adelaide, Australia
Flinders University, Adelaide, Australia
Albury Regional Art Gallery, Albury, Australia
Museum of Fine Arts, Boston, USA
Griffith University, Brisbane, Australia
Queensland Art Gallery, Brisbane, Australia
Australian National Gallery, Canberra, Australia
National Library, Canberra, Australia
Refco Inc, Chicago, USA
The National Museum for Photography,
 Copenhagen, Denmark
Folkwang Museum, Essen, Germany
DG Bank, Frankfurt, Germany
Tasmanian State Institute of Technology,
 Hobart, Australia
Museum of Fine Arts, Houston, USA
Tate Gallery, London, UK
MOCA Los Angeles, USA

BP Australia, Melbourne, Australia
Monash University, Melbourne, Australia
National Gallery of Victoria, Melbourne, Australia
Steve Vizard Foundation, Melbourne, Australia
Bayerische Staatsgemäldesammlungen,
 Munich, Germany
Museet For Santidskunst, Oslo, Norway
Art Gallery of Western Australia, Perth, Australia
Curtin University, Perth, Australia
Linda Pace Collection, San Antonio, USA
Centro Galego de Arte Contemporanea,
 Santiago de Compostela, Spain
Art Gallery of New South Wales, Sydney, Australia
Museum of Contemporary Art, Sydney, Australia
Museum of Contemporary Photography, Tokyo, Japan
Ulmer Museum, Ulm, Germany
Museum Moderner Kunst Stiftung Ludwig, Vienna,
 Austria

FILM UND VIDEO SAMMLUNGEN / FILM AND VIDEO COLLECTIONS

State Film and Video Library, Adelaide, Australia
Griffith University, Brisbane, Australia
Institute of Aboriginal Studies, ANU,
 Canberra, Australia
National Library, Canberra, Australia
State Film Centre, Melbourne, Australia
New York Public Library, New York, USA
West Australian Film Centre, Perth, Australia
West Australian Institute of Technology,
 Perth, Australia
Macquarie University, Sydney, Australia
Sydney University, Sydney, Australia
University of Technology, Sydney, Australia

AUSGEWÄHLTE BIBLIOGRAFIE / SELECTED BIBLIOGRAPHY

1999

Cate Mcquaid, *Free falling delivers Aboriginal perspective*, The Boston Globe, January 28, Boston, USA.

Thomas Wolff, *Laudanum für die Kunstwelt*, Frankfurter Rundschau, March 2, Frankfurt, Germany.

Leiche auf der Landstraße, Spiegel, March 22, Hamburg, Germany.

Tracey Moffatt & Gerald Matt, Una conversacion, Arte y Parte, No. 18, Madrid, Spain.

1998

Bill Stamets, *Art people: The making of an art queen*, Chicago Reader, November 20, USA.

Adrian Martin, *Tracey Moffatt's Australia*, Parkett, No. 53, Zürich, Switzerland.

Ewa Lajer-Burcharth, *A Stranger within*, Parkett, No. 53, Zürich, Switzerland.

David Crosby, *Tracey Moffatt*, Zoom, No. 26, May-June, Italy.

Dominique Baque, *La Photographie Plasticienne*, Un Art Paradoxal, Paris, France.

Susan Hapgood, *Tracey Moffatt at Dia*, Art in America, March, New York, USA.

David Morrow, *If This Is Art, Then I Really Like It*, C-International Contemporary Art, October, Toronto, Canada.

Strange Days, 3D, Sydney, Australia.

Giles Auty, *Quest of Significance*, The Weekend Australian, July 4–5, Australia.

Thomas Wolff, *Die Hitze, das Vergnügen, die Angst*, Frankfurter Rundschau, September 5, Frankfurt, Germany.

Michael Hübl, *Blues'n Balls*, Kunstforum International, No 141, July/September, Germany.

Birgit Sonna, *Echo aus der Zukunft*, Süddeutsche Zeitung, June 6, München, Germany

Dirk Schwarze, *Vom Zentrum an den Rand und zurück*, Süddeutsche Zeitung, June 4, München, Germany.

Gabriele Hoffmann, *Verschlungen in weißer Leere*, Stuttgarter Zeitung, April 28, Stuttgart, Germany.

Nicolai B. Forstbauer, *Balladen nebensächlichen Schreckens*, Stuttgarter Nachrichten, June 6, Stuttgart, Germany.

Mario Limbach, Im Sucher: *Entmenschlichung und Anonymisierung*, Esslinger Zeitung, May 5, Esslingen, Germany.

F. Schur, *Zwischen Sex, Gewalt und Glamour*, Prinz, May, Stuttgart, Germany.

Sabine B. Vogel, *Tracey Moffatt im Württembergischen Kunstverein und in der Kunsthalle*, Kunst Bulletin, June, Zürich, Switzerland.

Mario Limbach, *Gegen den Sturm der Bilder gestemmt*, Südwest Presse, May 8, Germany

Ludovica Pratesi, *Turn-of-the Century Reflections: Six Chapters on art and jeans*, Art Energie – Art in Jeans, Florence, Italy.

Karin Schulze, *Tracey Moffatt. Künstlich wie das Leben*, Der Spiegel – Kultur, May, Hamburg, Germany.

Elke Bockhorst, *Frauen vor Wüstenlandschaft. »Echolot oder neun Fragen an die Peripherie«. Eine Ausstellung in Kassel*, Frankfurter Rundschau, May 2, Frankfurt, Germany.

Ilona Lehnhart, *Das Rettende scheint wieder nah*, Frankfurter Allgemeine Zeitung, April 20, Germany.

Reiner Metzger, *Tracey Moffatt: Plot and Pleasure*, Noema, no. 47, April, Vienna, Austria.

Martin Pesch, *Tracey Moffatt*, Kunstforum International, No. 140, April, Germany.

Dorothee Baer-Bogenschütz, *Angekratzt – Bilderflut: Tracey Moffatt*, Kunstzeitung, April 20, Regensburg, Germany.

Susanne Lingemann, *Wunderland der falschen Träume*, Art, April, Hamburg, Germany.

Anke Kempkes, *Rollschuhfahrerinnen, Pasolini und Mad Max. Das Tracey Moffatt-Fieber*, Springerin, IV/1, May – March, Vienna, Austria.

Justin Spring, *Tracey Moffatt. Hunters & Collectors*, Art / Text, 60, Sydney, Australia.

Sebastian Smee, *The total eclipse of the mundane*, The Sydney Morning Herald, February 13–19, Sydney, Australia.

Doris Krumpl, *Hohe Kunst der Künstlichkeit. A View from Australia: Tracey Moffatt in der Kunsthalle Wien*, Der Standard, April 9, Vienna, Austria.

Joanna Mendelssohn, *Questions and alternative truth*, The Australian Friday, 6, Australia.

Dorothee Baer-Bogenschütz, *Am Anfang und Ende der Zivilisation. Rätselszenen aus dem australischen Outback: Tracey Moffatt in der L. A. Galerie*, Frankfurter Rundschau, January 29, Frankfurt, Germany.

Johanna Hofle, *Tracey Moffatt – A view from Australia*, Eikon, No. 24, Vienna, Austria.

Bruce James, *Tracey in Timbuktu*, Photofile, Sydney, Australia.

Reiner Metzger, *Down under Dramolette*, taz, May 14, Berlin, Germany.

Dena Shottenkirk, *Letter from New York*, C-International Contemporary Art, Issue 58, Toronto, Canada.

Giancarlo Politi & Helena Kontora, *Container of Information*, Flash Art, XXXI, Summer, Milano, Italy. .

Laurence Nassau, *A snapshot of 1997–1998*, NY arts, September, New York, USA.

Fortbewegung, die nur ein einziges Ziel kennt: das Ich, Die Welt, October 10, Berlin, Germany.

Kathrin Luz, *Im Exzeß der großen Gefühle und grellen Farben*, Noema, No 49, September, Vienna, Austria.

Kristian Sotriffer, *Das Triviale, der Traum, die Kunst*, Die Presse, April, Vienna, Austria.

1997

Lynne Cooke, *Tracey Moffatt: Free Falling* (catalogue essay), Dia Center for the Arts, New York, USA

Roberta Smith, *Real Life Tableaux, Natural Yet Startling*, Art Review / The New York Times, October 10, New York, USA.

Malin Wilson, *Truce: Echoes of art in Age of Endless Conclusion*, Artforum, December 12, New York, USA.

Jean Dykstra, *Tracey Moffatt: Portrait of the Artist*, Art and Auction, p. 62, New York, USA.

Charles Dee Mitchell, *Report from Santa Fe, New Narratives*, Art in America, November, New York, USA.

Vicki Goldberg, *The Artist Becomes A Storiesteller Again*, The New York Times, November 9, New York, USA.
Franklin Sirmins, *Tracey Moffatt – So many stories to tell,* Flash Art, Vol. XXX, No. 195, Milano, Italy; New York, USA.
Report from Sao Paulo, Art in America, March, New York, USA.
Anne Marie Freybourg, *Blick aus der Ferne* (catalogue essay in: On Dialogue), Haus am Waldsee, Berlin
Renate Puvogl, *Campo 6 – the Spiral Village*, Kunstforum international, No. 137, June/August, Germany.
Silvia Eiblmayr, *Zonen der Verstörung*, (catalogue essay in: steirischer herbst), Graz, Austria.

1995

Gael Newton & Tracey Moffatt, *Tracey Moffatt – Fever Pitch*, Piper Press, Sydney, Australia.
Julia Robinson, Antipodean Currents, The Guggenheim Museum Soho, New York, USA.
Gael Newton, *Tracey Moffatt*, (catalogue essay in: Australian Perspecta 95), Art Gallery of New South Wales, Sydney, Australia.
Susanne Lingermann, *Tracey Moffatt*, ART, October, Hamburg, Germany.
Ewen McDonald, *Tracey Moffatt at Karyn Lovegrove and Mori*, Art in America, July, USA.
Michael Fitzgerald, *Technicolor World*, TIME Magazine, August 7, Australia/Pacific.
Adrian Martin, *The Go-Between*, World Art Magazine, No. 2, p. 24–29, Melbourne, Australia.

1994

Gael Newton, *See the woman with the red dress on … and on … and on …*, Art and Asia Pacific, Vol. 7 No. 2, Sydney, Australia.
Patricia Mellencamp, *Haunted History: Tracey Moffatt and Julie Dash*, Discourse, Indiana University Press, Winter 93/94, USA.

1993

Tait Brady, *Bedevil*, Melbourne Film Festival Catalogue, Melbourne, Australia.
Penny Webb, *Tracey Moffatt's Bedevil – A Film Inscription of Three Ghost Stories*, Agenda, No. 34, Summer, Sydney, Australia.
Karen Jennings: *Experimenting with Difference. Sites of Difference. Cinematic representations of Aboriginality and Gender*, Australian Film Institute, Australia.
Marcia Langton: *Well, I heard it on the radio and I saw it on the television. An essay for the Australian Film Commission on the politics and aesthetics of filmmaking by and about Aboriginal people and things*, Australian Film Commission, Australia.
Laleen Jayamanne, *A Sri Lankan reading of Tracey Moffatt's Night Cries*, Feminism and the Politics of Difference, ed. by Sneja Gunew and Anna Yeatman, Allen & Unwin, Australia.
Jacques Delaruelle, *On the verge of saying nothing*, (catalogue essay in: Adelaide Festival 1993), Visual Arts Program, Adelaide, Australia.
John Wojdylo, *Bedevil*, Cinema Papers No. 96, Sydney, Australia.
Lesley Stern, *When the Unexplained Happens*, Photofile, No. 40, Sydney, Australia.
John Conomos, *Bewitched*, Art and Australia, Vol 31 No. 2, Sydney, Australia.
Henri Behar, *Le pillage du grenier familial*, Le Monde, Mai, Paris, France.
Bedevil – Tracey Moffatt interviewed by John Conomos and Raffaele Caputo, Cinema Papers, Vol. 93, Sydney, Australia.
Deb Verhoeven, *Just Trust the Text, Don't Colour it*, Art Link, Vol. 13 No. 1.

1992

Jyanni Steffansen, *Scanning Photoworks – Adelaide Festival and Fringe. Tracey Moffatt – Pet Thang*, Photofile, 35.
Warwick Adler, *Photography and Eroticism*, Art and Australia, Vol. 30 No 1, Spring, Australia.

1990

Erica Carter, Radical Difference, New Formations, No. 10, Spring.
Paul Cox, *Night Cries in Cannes*, Art Monthly, August.
Scott Murray, *Tracey Moffatt – Night Cries. A rural tragedy*, Cinema Papers, No 79, May.
Anne Rutherford, *Night Cries - A Rural Tragedy*, Art Link, Vol. 10 No. 1–2.

1989

Anne Marie Willis, *Picturing Australia – A History of Photography*, Angus & Robertson, Australia
Patrick Crogan, *Tracey Moffatt – Something More*, Photofile, Spring, Sydney Australia.
Fiona Mackie, *A Fractal Deframing in Film, Tracey Moffatt's Night Cries A Rural Tragedy*, Photophile, 31.

1988

Gael Newton, *Shades of light – Photography and Australia*, Australian National Gallery, Australia.
Helen Ennis: *Australian Photography. The 1980s*, Australian National Gallery, Australia.
Helen Grace, *Still Moving*, Art and Australia, Vol. 26 No. 1, Australia.
Anne Rutherford, *Changing Images – An Interview with Tracey Moffatt*, Aboriginal Culture Today, Dangeroo Press, Australia.

FILM & MUSIC RECORDS

1993

Bedevil, Ronin Films – The Study Guide, Canberra, Australia.
Bedevil – Original Motion Picture Soundtrack Recording, Music composed and conducted by Carl Vine, One M Records PTY Ltd. Sydney, Australia.

IMPRESSUM / COLOPHON

Herausgeberin/Editor
Brigitte Reinhardt
Ulmer Museum

Ausstellung und Katalog/Exhibition and catalogue
Brigitte Reinhardt, Barbara Renftle

Übersetzungen/Translations
John S. Southard

Fotonachweis/Photo credits
L.A. Galerie, Frankfurt a.M.
Lylie Fisher
Harald H. Schröder, Frankfurt a.M.

Sekretariat/Secretariat
Gabriele Wilde, Sabine Emminger

Kataloggestaltung / Satz/Graphic design/Typesetting
Eduard Keller-Mack

Gesamtherstellung/Printed by
Dr. Cantz'sche Druckerei
Ostfildern-Ruit

Published by Hatje Cantz Publishers
Senefelderstr. 12
73760 Ostfildern
Tel. (0)711- 4405-0
Fax (0)711- 4405-220
Internet: www.hatje cantz.de
Distribution in the US
D.A.P., Distributed Art Publishers, Inc.
155 Avenue of the Americas, Second Floor
USA-New York, N.Y. 10013-1507
Tel. 0 01/2 12/6 27 19 99
Fax 0 01/2 12/6 27 94 84

ISBN 3-7757-0874-X

Printed in Germany